T0097251

THE MODERNIST

TRADITION

IN AMERICAN

WATERCOLORS

1911-1939

Mary and Leigh

Block Gallery

Northwestern

University

1991

I

THE MODERNIST

TRADITION

IN AMERICAN

WATERCOLORS

1911-1939

Marilyn Kushner

Curator

Mary and Leigh

Block Gallery

Northwestern

University

1991

The Modernist Tradition in American Watercolors: 1911-1939 is
published to accompany an exhibition of the same title on view at
the Mary and Leigh Block Gallery from April 5, 1991 through June
22, 1991.

Copyright © 1991

Mary and Leigh Block Gallery, Northwestern University

Library of Congress Cataloguing in Publication Data

Kushner, Marilyn S., 1948-
The modernist tradition in American Watercolors, 1911-1939 /
Marilyn Kushner.
p. cm.
Catalog of an exhibition to be held at the Mary and Leigh Block
Gallery from 4/5/91 to 6/22/91.

Incudes bibliographical references.

1. Watercolor painting, American – Exhibitions.
2. Watercolor painting – 20th century – United States – Exhibitions.
3. Modernism (Art) – United States – Exhibitions.
I. Mary and Leigh Block Gallery.
II. Title.
ND1808.K87 1991
759. 13'074'7731 – dc20

ISBN 0-941680-09-6

CONTENTS

LENDERS TO THE EXHIBITION

Anonymous lender
Baker/Pisano Collection
The Brooklyn Museum
The Carnegie Museum of Art
Columbus Museum of Art
D. Bradley/R. Blacher
Mr. and Mrs. W. John Driscoll
Edsel and Eleanor Ford House
Mrs. Volney W. Foster
Irwin Goldstein, MD
Kennedy Galleries
Eleanor and Tom May
Elizabeth Moore
The Pennsylvania Academy of the Fine Arts
Gerald Peters Gallery/Hirschl & Adler Galleries

Milwaukee Art Museum
The Montclair Art Museum
Munson-Williams-Proctor Institute Museum of Art
Pensler Galleries
Arthur J. Phelan, Jr. Collection
Private collections
Françoise and Harvey Rambach
Rose Art Museum, Brandeis University
San Diego Museum of Art
Michael Scharf
Shearson Lehman Brothers Collection
Robert and Anna Steiner
The Terra Museum of American Art
Whitney Museum of American Art
Zabriskie Gallery

Preface and Acknowledgements

It is no easy task to define the beginnings of a national identity, to illustrate the first stirrings of cultural independence, or provide clear insight into that which defines new approaches to the very nature, structure and aspirations of the visual arts. It is a daunting experience to attempt to give definition to the spirit of an age in which the very fabric of the economic, political, and social life of a society is undergoing change. Yet *The Modernist Tradition in American Watercolors: 1911-1939* reflects just such an attempt in its understanding of America and American art as it encountered the modern age.

The first decades of the twentieth century comprise a period of dizzying change and vitality often characterized by the contradictions inherent in the pace of such change. It is a period that witnessed two wars and an unsatisfying peace, that encountered an economic boom shattered by the worst depression in American history, that saw the development of a new American landscape in the form of the skyscraper yet heard the future President and current Governor of New York, Franklin Delano Roosevelt, at the dedication of the symbol of this new urbanism (the Empire State Building) express his confusion at this change when he stated:

> I am still a little awestruck... As a simple countryman who has been down here in New York for twenty-five years, I still think in terms of fields and creeks. And when I looked out north and saw Central Park, it reminded me of the sides of my cow pasture at Hyde Park.

It is the time in which Carl Sandburg collected and published American folk music, when Mencken documented the American language, when Copeland attempted to have his music reflect the sounds of America and when jazz became a truly American musical experience. Yet this is also the time of expatriate artists such as Gertrude Stein, Josephine Baker, Ernest Hemingway, and Patrick Henry Bruce all of whom felt the need to distance themselves geographically by relocating to Europe to gain the perspective necessary to respond to modernist developments.

The Modernist Tradition in American Watercolors: 1911-1939 examines the period defined by the first American exhibition of Cezanne's watercolors in 1911 and the beginnings of World War II. It provides the first glimpse at the modernist experimentations that were occurring in watercolor and the appropriation of the watercolor medium as an American form of expression. The exhibition presents such artists as Charles Burchfield, Arthus B. Davies, Stuart Davis, Charles Demuth, Arthur Dove, George Grosz, John Marin, Georgia O'Keeffe, Morgan Russell, Joseph Stella, Max Weber, and others, who imbued their work with an American spirit and theme based upon modernist principles.

That this exhibition has occurred at the Mary and Leigh Block Gallery will come as no surprise to those familiar with the museum's mission of presenting new ideas and research in the history of the visual arts. Numerous exhibitions in the immediate past have explored aspects of the history of modernism. Several currently under development will continue to do so in the coming years. Organized by Marilyn Kushner, Curator of the Montclair

Art Museum and one of the most promising scholars of a younger generation of art historians, *The Modernist Tradition* breaks new terrain and asks questions (some left unanswered) in a manner that is the purview of a university museum. It has been a pleasure and privilege to work with a friend of fifteen years and a former colleague in graduate school.

Drawn from more than 30 public and private collections from throughout the United States, *The Modernist Tradition* could not have occurred without the dedication, professionalism, and trust of many individuals. I would like to extend my personal thanks to all of the collectors and museums who have lent to this exhibition (listed on page VI). Their collecting acumen and their willingness to allow these works to be shared with the broader public and made available for scholarly discussion is deeply appreciated.

To be certain, no exhibition occurs at the Block Gallery without the commitment of a small but highly professional staff. Jim Bonamici, the Gallery's Assistant Director, has handled the logistical arrangements for *The Modernist Tradition* and the communication with an array of lenders with great dexterity. His installation of the exhibition follows the same clarity and design forte that have been the hallmark of his career at the Gallery. His departure this semester will leave a void that will be difficult to fill. Lynn Curry Wade, Curator of Interpretive Programs, has been responsible for the organization of all of the symposia, lectures, films, concerts, tours, didactic information presented in the Gallery and other programs held in conjunction with the exhibition. Lynn's knowledge and creative finesse make possible the interpretive function of the Gallery that allows meaningful access to the works on view by a broad range of the Gallery's constituencies. Diane Szczepaniak, responsible for membership and public relations, has been crucial in insuring that a broad spectrum of the public has knowledge of the exhibition and the ability to participate in our programs and our future. Gina Green, Departmental Secretary, has been key to the smooth functioning of almost all aspects of our project that has needed attention to detail and logistical expertise. Although not technically serving on the staff of the Gallery it is incumbent upon me to also recognize the extraordinary efforts of three individuals: Susan Cooke for organizing the annotated checklist appearing in this catalogue; Marion Morgan for editing the catalogue; and Chris Senese for aspects of the catalogue design.

There are others within the Northwestern community that have been instrumental in bringing this exhibition to fruition. Bill Park in Risk Management, Eric Wachtel and Will Higgins in Budget, Linda Matsumoto and Stephanie Russell in University Relations, James Yood in the Department of Art Theory and Practice, Larry Silver in the Department of Art History, Don Owens in the Music School, are just a few who have been especially generous of their time and expertise.

Since the inception of the Gallery, the Friends of the Mary and Leigh Block Gallery have been crucial to our success and development. *The Modernist Tradition* would not have been possible without the hundreds of patrons who provide the funds necessary to organize exhibitions and interpretive programs.

Additionally, the Board of Directors of the Friends has provided the leadership and commitment in the planning of events that has set an example for other museum volunteer organizations. It has been an absolute pleasure to continue to work with the Friends on behalf of the Gallery and Northwestern.

There are many other individuals whose input and dedication have made this exhibition a reality. I and the entire staff of the Gallery extend our appreciation and thanks to all of the following: William C. Agee, Professor, Hunter College, New York; Alejandro Anreus, Associate Curator, The Montclair Art Museum, New Jersey; Scott Atkinson, Curator, The Terra Museum of American Art, Chicago; Anselmo Carini, Associate Curator of Prints and Drawings, The Art Institute of Chicago; Anita Duquette, Manager, Rights and Reproductions, Whitney Museum of American Art, New York; Barbara Haskell, Curator, Whitney Museum of American Art, New York; the entire staff of Heritage Press but especially Dave DeLana, Bradley W. Rubac, Vickie Beard, and Terrie Rubac; Jayne Johnson, Registrar, The Terra Museum of American Art, Chicago; Robert J. Koenig, Director, The Montclair Art Museum;

Lisa Lorch, Sotheby's, New York; Deborah Lyons, Advisor, Hopper Collection, Whitney Museum of American Art, New York; James Mundy, Chief Curator, Milwaukee Art Museum, Milwaukee, Wisconsin; M.P. Naud, Director, Department of American Art, Hirschl & Adler Galleries, Inc., New York; Martin E. Peterson, Curator of American Art, San Diego Museum of Art, California; Alan Pensler, Pensler Gallery, Washington, D.C.; Larry Silver, Professor, Northwestern University, Evanston, Illinois; Barbi Spieler, Associate Registrar, Traveling Exhibitions, Whitney Museum of American Art; Jeanette Toohey, Assistant Curator, Prints & Drawings, Pennsylvania Academy of Fine Arts; Jonathan Weinberg, Assistant Professor, Yale University, New Haven, Connecticut; Eric P. Widing, Richard York Gallery, New York; Shirley Wiley, Curatorial Secretary, The Montclair Art Museum, New Jersey.

David Mickenberg

Director

I. INTRODUCTION

This essay and the exhibition that accompanies it help define the state of modernist watercolor painting in American art between 1911 and 1939. The artists under consideration were chosen because their watercolors are important statements in the story of American watercolor and in the history of early twentieth-century modernist painting.[1] Both the principal watercolor artists and the issues of an historical perspective encompassing important critics and some dealers are considered.

This study begins in 1911, the year Paul Cézanne's watercolors were first shown in America at Alfred Stieglitz's gallery "291." Watercolor, with the capacity it offers artists to paint in translucent layers, was an anchor of Cézanne's structural ideas, and his technical mastery of the medium likely served as an inspiration to aspiring watercolor painters who saw these works. 1939 has been chosen as a terminal point for this study because it marks the opening of World War II, and with it the beginning of a new set of circumstances that defined American art in the following decades.

Between 1911 and 1939, American art evolved from being a satellite of European art (in the early teens) to discovering and establishing its own identity (during and immediately after World War I) and then to becoming isolationist from the late 1920s throughout the 1930s. During the twenty-eight years in question, many avant-garde artists were working in watercolor. While it did not capture the same amount of attention as did oil painting either from art patrons or critics, some supporters continually lauded its merits. And crucially, quite a few artists chose to do their important work in both oil and watercolor. In the teens, a few artists made watercolor painting the mainstay of their work. By the early 1920s, after critics began to recognize and actually praise work in the medium, other artists followed suit. Throughout the 1920s and 1930s, notable artists continually produced significant work in watercolor.

One reason that American artists embraced watercolor painting in the first part of the twentieth century was because its spontaneity and immediacy appealed to them. This rawness and immediacy associated with the medium must have appealed to the American character which, throughout literature and history, was characterized as brash and energetic. Carl Sandburg's 1914 evocation of Chicago, "with lifted head singing so proud to be alive and coarse and strong and cunning," embodies this attitude and might also be used to describe a persona that had to battle the elements and work hard to establish and maintain the American nation.[2] Such a national personality would be attracted to an art that embodied those attributes. American gallery owner and art editor Robert Coady wrote that American art was "not a refined granulation nor a delicate disease...it is an expression of life—a complicated life—American life."[3] He later commented that American art was actually outside "our art world."[4] By this he meant that American art could be found not in the art world of the galleries and the studios but in American society and culture. American art was immediate; it reflected the American soul; it was the "spirit of the Panama Canal. It's in the East River and the Battery. It's in Pittsburgh and Duluth. It's coming from the ball

field, the stadium and the ring."[5] In other words, American art had to depict the sometimes gritty, frequently industrious, character that was building the nation. Even in its leisure pursuits—the ball field, the stadium and the [boxing] ring—the American character was not refined; it was bold. While watercolor *could* be refined, the quickness and thus immediacy with which watercolor had to be applied and the rawness of the image that, once put on the paper, could not be changed were features that synchronized with the American character.

There were many other reasons why artists in the United States concentrated upon watercolor. Since watercolor had not been recently identified with any particular country—had not been "colonized"— perhaps American artists felt that they could embrace it and make it distinctly their own. Thus, when Charles Demuth depicted America, especially in the teens, he did it in watercolor. Similarly, John Marin expressed the urban energy of America as well as its rural beauty in watercolor. Some artists turned to the spontaneity of watercolor for its expressive qualities, and some turned to it for the possibilities of abstraction it afforded them. It is, finally, not coincidental that a large number of the important watercolors from this period are landscapes. The organic quality of the landscape image, which is especially associated with American art, is well suited to the watercolor technique, which seems to breathe with a life of its own.

One cannot conduct a serious study of early twentieth-century American watercolor without dealing with the significant contribution that certain figures made to the medium's development. For example, Alfred Stieglitz supported the idea of works of art on paper throughout his career as a gallery owner and, in the years that he operated "291," showed works on paper more than oil paintings. (His partiality to works on paper is undoubtedly related to his active career in photography and his insight into the possibilities of such works.) Notably, many of the artists who created watercolors during the teens were Stieglitz's artists—Charles Demuth, John Marin, Georgia O'Keeffe, Abraham Walkowitz and Max Weber principal among them. For John Marin and Charles Demuth, watercolor, rather than oil, was their *primary* medium.[6] Both were master technicians whose determination to paint watercolors resulted in the creation of masterpieces of American art. Most of Georgia O'Keeffe's color images from the teens were watercolors. The paintings of these three artists served as a signal to other artists that serious work could be done in a medium that had been previously thought to be minor. An example of the developing attitude towards watercolor can be observed in the critical stance taken in relation to Marin's work. Lewis Hind wrote, "I admit that what interests me especially in Marin is that he has the courage and the integrity to confine himself to exploration in watercolor."[7] Years later, noted art historian Sherman Lee commented that Marin was, "in a way, the primitive of watercolor *painting* in this country. Without attempting to imitate oil, he has finally succeeded in restoring watercolor to the position of a major medium."[8] By the 1920s, watercolor painting had become known and accepted to the point that critics began to see its importance and more artists ventured into the medium.

This is one of the first studies to deal with the critical reaction to watercolor painting in the first part of the century. Some writers in the early twentieth century took watercolor much more seriously than do contemporary scholars who write about the period.[9] Some critics were able to discern the difference between the conservative exhibitions of the watercolor societies and the more successful endeavors of avant-garde artists. Closer investigation of these contemporary accounts as well as closer examination of the works reveal that watercolor is a medium that deserves more serious study than it has previously received. While this inquiry poses as many questions as it answers, it serves as a springboard for future investigations into this important topic.

NOTES

1. The artists to be included in the exhibition are Oscar Bluemner, Charles Burchfield, Charles Demuth, Arthur B. Davies, Stuart Davis, Preston Dickinson, Arthur Dove, George Grosz, Edward Hopper, John Marin, Georgia O'Keeffe, Walter Pach, Morgan Russell, Morton Schamberg, Charles Sheeler, Joseph Stella, Abraham Walkowitz, Max Weber, John Von Wicht and William Zorach. Many of them will be considered for this essay.

2. Carl Sandburg's poem "Chicago" quoted in Roderick Nash, ed., *The Call of the Wild (1900-1916)* (New York: George Braziller, 1970), 147-48.

3. Robert J. Coady, "American Art," *The Soil* 1 (December 1916), 4.

4. Robert J. Coady, "American Art," *The Soil* I (January 1917), 55.

5. Ibid., 55.

6. While Demuth was not in the Stieglitz stable in the teens (his work was sold by Charles Daniel), Demuth always had very close associations with Stieglitz and his artists.

7. C. Lewis Hind in "Art and I," Henry McBride Papers, Roll NMcB11, Archives of American Art, Smithsonian Institution, Washington, D.C.

8. Sherman E. Lee, "A Critical Survey of American Watercolor Painting" (Ph.D. diss., Western Reserve University, 1941), 267.

9. Most contemporary studies of watercolor painting in the period being considered have either glossed over any importance of the medium or have said that watercolor has been of tangential importance, second to oil painting. An example is Graham Reynolds, who wrote, "It cannot be said that watercolour as such played a determining role in these trends [early twentieth-century abstract painting], but these developments are all faithfully reflected in its own progress." (See Graham Reynolds, *Watercolours: A Concise History* [London: Thames and Hudson Ltd., 1971], 163.) Even Donelson F. Hoopes, when writing about this period of American watercolor painting, did not speak to the importance of the medium but chose rather to write about the biographical information of the watercolor painters of the early twentieth century. (See Donelson F. Hoopes, *American Watercolor Painting* [New York: Watson-Guptill Publications, 1977], 147-52.) Karl Kusserow, writing most recently on the subject for an exhibition at Yale University, commented that early twentieth-century American abstractionists used watercolor frequently, but he did not determine why this was the case, nor did he place the watercolor artists within a broader context. (See Yale University Art Gallery, *Watercolor in America*, essay by Karl Kusserow [New Haven: Yale University Art Gallery, 1990], 6-14.) Stebbins was one of the few scholars to recognize the extraordinary quality of American watercolors in the first part of the twentieth century when he wrote that the "early American modernists produced some of the most extraordinary drawings and watercolors in our history" (Theodore E. Stebbins, Jr., *American Master Watercolors and Drawings* [New York: Harper & Row, 1977], 298). Finally, in the introduction to his 1922 book, *American Water-Colourists*, A.E. Gallatin noted, "During recent years a number of America's most talented artists have made a serious study of the technique of water-colour drawing, with admirable results." (A.E. Gallatin, *American Water-Colourists* [New York: E.P. Dutton & Company, 1922], 1).

II. A Brief History of Watercolor

Watercolor was one of the first painting techniques used by early man, who wet earth pigments and painted with them. Today, watercolor paints are fine ground pigments, bound with gum arabic, but soluble in water. Due to the translucent quality of the pigment, watercolor is a very exacting medium because mistakes cannot be "fixed" or overpainted. A talented watercolor artist is able to control the water component on the brush, on the paper and in the paint. Another important feature of watercolor is the white paper ground that creates its own light by shining through the transparent pigments. If a different effect is desired, a more opaque white, or gouache, can be added to the watercolor, giving the paint a less translucent quality.[1]

Modern watercolor painting began in Germany with Albrecht Dürer (1471-1528), whose landscapes and images of nature remain among the finest watercolors done.[2] (*The Great Piece of Turf*, 1503, is renowned for its technical beauty and exactly detailed rendition of nature.) Dürer's work is particularly remarkable because he had no precedents from which to work.

Dürer's peers did not share his enthusiasm for the medium, and for the next 100 years watercolor painting was relegated to the role of secondary touch-up work on prints and drawings. It was not taken up in earnest again until the seventeenth century in Holland, where art patrons' demand for watercolors grew as Dutch artists embraced the medium, especially depicting genre and landscape scenes. Jacob Jordaens (1593-1678), Adriaen van Ostade (1610-1685) and Cornelius Dusart (1660-1704) were among the Dutch artists who worked in watercolor during this period.

In the eighteenth century the mantle of watercolor painting was transferred to England, when such artists as Alexander Cozens (early 1700s-1786), John Robert Cozens (1752-1797) and Paul Sandby (1730-1809) recorded their travels in watercolor because it was a portable medium. By 1804 the Society of Painters in Watercolours was established in England, and the medium was so popular that a rival organization was founded in 1807—the New Society of Painters in Miniatures and Watercolours.

Many critics regard Joseph Mallord Turner's (1775-1851) mastery of watercolor as seminal in exploring the medium's expressive possibilities in the age of romantic painting. While he may be regarded as the maestro of the early nineteenth century in England, others demonstrated proficiency in watercolor as well. Richard Bonnington's (1802-1828) renditions of the English countryside were exhibited in the Paris Salon of 1822, and Samuel Palmer's (1805-1881) visionary images (inspired by Blake's work) were powerful, accomplished works of art.

By the early nineteenth century, French painters were using watercolor for its technical and expressive potentials. Eugène Delacroix (1798-1863) was foremost in adapting watercolor techniques to his emotionally charged romantic images. Other French artists who worked well in watercolor were Eugène Isabey (1803-1886), Paul Huet (1803-1869), Paul Gavarni (1804-1866) and Constantin Guys (1802-1892).

Watercolor painting gained recognition in the United States in the 1860s. In 1866 the American Water Color Society was founded.

Its first president was Samuel Colman, and one of its founding members was Winslow Homer, whose ability as an artist was most successfully manifested in watercolors. Indeed, Homer can be considered the seminal figure in the history of American watercolor.

The list of nineteenth-century European and American artists working in watercolor is a long one. One need only refer to the watercolor work of such artists as Honoré Daumier (1808-1879), Jean-François Millet (1814-1875), John La Farge (1835-1910) or John Singer Sargent (1856-1925) to recognize that watercolor was not ignored by the most accomplished artists. Neither was it their primary mode of expression, however. It would take until the twentieth century for watercolor to be fully accepted in the mainstream of American art.

The artist who brought recognition to watercolor painting in the twentieth century was Paul Cézanne (1839-1906). While he painted watercolors throughout most of his career, it was not until a year after his death, 1907, at Bernheim-Jeune in Paris, that a sizeable number of his watercolors (seventy-nine) were shown. That same year, a Cézanne retrospective exhibiting more than fifty oils and watercolors was held at the Salon d'Automne. At this time, the French began to take notice of him. It was not until 1911, when the American public was able to see Cézanne's watercolors at "291," that his work began to influence artists working in America in terms of both compositional structure and the medium of watercolor. Cézanne manipulated the possibilities of the medium in a manner that simultaneously revealed the planar structure of his images and flattened out the composition through the relationship of the translucent pigments to the paper ground. Once younger artists recognized what Cézanne had done, a revolution occurred in the way that artists handled watercolor. They no longer considered watercolor only as a pigment that would reproduce the likeness of an image, but also saw it as a tool that would help them achieve their structural goals.

NOTES

1. Because the luminosity of the paper, which is so critical in a watercolor composition, is not as important in gouache, most of the works chosen for this exhibition were not painted with gouache.

2. For a more complete history of watercolors see Graham Reynolds, *Watercolors: A Concise History* (London: Thames and Hudson Ltd., 1971).

For the history of American watercolors see Theodore E. Stebbins, Jr., *American Master Drawings and Watercolors* (New York: Harper & Row, 1976); Christopher Finch, *American Watercolors* (New York: Abbeville Press, 1986); Donelson F. Hoopes, *American Watercolor Painting* (New York: Watson-Guptill Publications, 1977).

III. THE INTRODUCTION OF MODERN WATERCOLOR TO AMERICA

The years between 1911 and World War I were highly significant to the development of watercolor in America. Not only were there important sales and exhibitions, but the early part of the decade was also a period of searching and groping for the definition of the true "American" soul; it was also a time of searching and groping for a definition of American art.

America in the second decade of the twentieth century was characterized by a swelling of national pride. In 1913 the Woolworth Building, sixty-eight floors high, opened in New York City. The Panama Canal, a technological miracle, was completed in 1914. Economic prosperity was increasing, and the population, especially that of the cities, grew exponentially because of the large numbers of new immigrants arriving at American ports every day. The beginning of hostilities in Europe in 1914 drove French, German and Italian artists, escaping the dangers of war, to American shores. These new arrivals had firsthand knowledge of European modern art developments because they had been in the midst of them (Marcel Duchamp and Francis Picabia are two of the most well-known artists who came to America). Coincident with these socioeconomic changes, intellectual ferment was occurring in the United States; America was seeking to define her own personality rather than be subject to other cultural identities.

In 1913 critic Hutchins Hapgood wrote,

> We are living at a most interesting moment in the art development of America. It is no mere accident that we are also living at a most interesting moment in the political, industrial, and social development of America. What we call our "unrest" is the condition of vital growth, and this beneficent agitation is as noticeable in art and in the woman's movement as it is in politics and industry.[1]

The "agitation" in art was defining a national cultural character, with the 1913 Armory Show in New York, Chicago and Boston playing a major role in this process. More than 300,000 people saw the exhibition, which displayed the work of avant-garde European artists as well as the contemporary work of Americans. Suddenly, one did not have to visit "291" to know about European abstract art, and for the first time, American artists were able to see their work hanging next to the work of Europeans.[2] The inevitable comparison created by this juxtaposition generated a definition of the character of American art. Arthur B. Davies very eloquently stated the situation in his review of the Armory Show. America, he wrote,

> with its great appetite for everything good in the world, should find in this exhibition a new stimulus, a fact as great as the declaration of our political independence. We have heretofore been but a foundling on the shore of art, and to no negligible extent a prey to the successful influences which, glamorous, push the world this way and that, without, as a matter of fact, greatly moving it. We have youth, energy, ambition—we should do great things when we have found our conception, found our individuality, thrown off the traditional shackles and become free men, looking at naked nature with naked eyes.[3]

The story of twentieth-century American watercolor coincides with this era that defined the nature of America's spirit and cultural being. While the embarkation point for this study is 1911, mention must be made of the sale of Sargent's watercolors to the Brooklyn Museum two years earlier. In 1909 Knoedler's in New York mounted an exhibition of Sargent's watercolors, eighty-three of which were purchased by the Brooklyn Museum. (The Boston Museum of Fine Arts had hoped to acquire these works; however, Brooklyn was able to move more rapidly on the deal.[4]) The transaction received considerable attention, and the watercolors were consistently out on loan for exhibition at other institutions. (Indeed, the Boston Museum of Fine Arts borrowed the watercolors for a show in 1909.) About the sale, Helen Appleton Read wrote that "The Sargent water colors were purchased in 1910, and the widespread publicity attached to this event had considerable influence in stimulating an interest in water color painting."[5]

Many types of watercolors were being seen by the American public. The American Watercolor Society, which had been active for decades, mounted annual exhibitions of works by its members. The society comprised a conservative body of artists whose membership did not include any of the people most often associated with the modernist movement.[6] A reviewer of the 1911 exhibition remarked that many people were disappointed with watercolor painting probably because the artists in the exhibition were seeking from watercolor what they traditionally sought from oil painting.[7] A tight, controlled approach was recognized by this reviewer as ineffective in a medium whose physical properties could be fluid and free.[8] In contrast, other American artists quite possibly recognized that the spiritual freedom of expression they sought as well as new solutions to the structural questions they were exploring could be better investigated in watercolor than in oil. Sargent's watercolors already showed precedent for this, as did Cézanne's watercolors shown in New York for the first time in the spring of 1911.

From March 1 until March 25, 1911, Alfred Stieglitz exhibited twenty Cézanne watercolors at "291."[9] The Cézannes, borrowed for this exhibition by Edward Steichen from Bernheim-Jeune in Paris, were the first of his watercolors to be seen by the American public. They included only one still life and a few figural images; the remainder were landscapes.

Cézanne's reputation had preceded him to the United States. Just the previous November, twenty-one of his paintings were included in an important post-impressionist exhibition organized by Roger Fry at Grafton Galleries in London. There Fry had determined that Cézanne was the cornerstone of all modern art.[10] Indeed, Fry even then included Cézanne in the traditional and vaunted heritage of French art when he wrote that "Cézanne is, in fact, one of the most intensely and profoundly classic artists that even France has produced."[11] This opinion of Cézanne's significance reached New York and began to prepare the small art-educated public for what it would see in the 1911 exhibition. However, neither this praise nor Stieglitz's belief that Cézanne was possibly the "greatest artist of the last hundred years[12]" were sufficient to insure a completely

positive response to the show. For example, Arthur Hoeber wrote in the *New York Globe*, "To the man hungry after art they fail to supply nutrition; on leaving you have your appetite still with you!"[13] In 1919 Stieglitz was to write to Henry McBride that New York "had laughed...at the exhibition at 291 of Cézanne's water-colors—Cézanne's introduction to America."[14] Stieglitz must have been strongly affected by the negative critical response, because years later he wrote that he would "never forget what happened...when I showed the Cézanne water-colors. The absolute neglect of them. Even John Quinn & Agnes Meyer etc..."[15]

Favorable reaction did come from the reviewer for the *New York Times*, who said that the works were "quiet and cool and self-possessed," and from the reviewer for the *Brooklyn Daily Eagle*, who wrote that the "first impression is that the pictures are marvelous for delicacy, lightness of atmosphere, suggestiveness and simplicity."[16] Artists also reacted favorably. Both Man Ray and Marsden Hartley liked the exhibition, and the only work that was sold out of the show went to another artist—Arthur B. Davies.[17]

Indeed, Hartley felt that a new group of American artists had come to age since Cézanne, stating that "since Cézanne art will never, cannot ever be the same."[18] He continued to write that in this atmosphere a new native tradition was building the foundation for American art, in which watercolor played an integral part. "There is then a fine American achievement in the art of watercolor painting," Hartley wrote. This tradition "may safely be called at this time a localized tradition. It has become an American

realization."[19] The feeling of some that watercolor had become an "American" medium helps explain its characterization as an integral element of modernist American art in the first part of the twentieth century.

This link between Cézanne, watercolor and modern art was recognized by Holger Cahill when he wrote about Cézanne in the introduction to the catalogue for a watercolor exhibition in Newark in 1930. "Cézanne," Cahill commented, "gave a new impetus to the watercolor art with his penetrating study of spatial relations which he put down with transparent and sensitive washes."[20] It is fortuitous that the introduction of Cézanne's watercolors to America occurred at the very time when American artists were grappling with cubism and abstraction in modern art. The use of watercolor with its layers of wash was especially suited to a cubist style, which defined the structure of an object (and image) by presenting the geometric principle of the existence of planes in nature. By virtue of the translucent properties of the pigment and the manner in which it is applied to paper, watercolor is a "planar" medium. This is especially evident in Walter Pach's *Untitled* painted in 1914 (Cat. No. 38). The translucent watercolor pigment is applied in a manner where several layers of paint visibly sit upon each other, creating an awareness of the structure of the object. One can see this in the coffee pot and in the upper left portion of the flower pot.

Another artist whose work was clearly influenced by the structural aspects of Cézanne's watercolors was Morgan Russell. Though Russell was not working in the United States but in Paris in the

teens, he was an American artist who was painting in watercolor and, as such, merits consideration in this study.[21] Russell first began to study Cézanne's work in 1910—Russell's notebooks are filled with references to the master and, indeed, in 1910 Russell borrowed from Leo Stein a Cézanne painting of five apples in order to study the French painter's methods. Russell was especially attracted to the manner in which Cézanne achieved structural solidity through color.[22] This can be seen in *Still Life (Cat. No. 40)*, where Russell used the translucent watercolor wash and white paper ground to explore the structure of the apples and build up from the center of the object. The ability to layer watercolor facilitated the creation of a scaffold which eventually produced the final image. In this image as well as other representational works that he painted, Russell visualized the core of an object and constructed the scaffold out from that.

Alfred Stieglitz influenced the development of American watercolor painting not only because he was the first to show Cézanne in America, but also because of his positive attitude towards works on paper. Stieglitz once declared that he did

> not see why photography, water colors, oils, sculptures, drawings, prints...are not of equal potential value. I cannot see why one should differentiate between so-called "major" and "minor" media. I have refused so to differentiate in all the exhibitions that I have ever held.[23]

Stieglitz already had been instrumental in successfully challenging the American public's preference for impressionism by his introduction of straight photography and his support for artistic photography in general through "The Photo-Secession," a group he created in 1902. The majority of works that Stieglitz showed at "291" were works on paper—photographs, prints, drawings and watercolors.[24] Because Stieglitz supported artists' efforts in this area, a small but important segment of the public became accustomed to seeing significant art forms on paper.

Accordingly, many of Stieglitz's artists chose to work on paper. Charles Demuth, John Marin, Georgia O'Keeffe and Abraham Walkowitz all exhibited with him and selected watercolor as their primary medium at some time during their careers. Others, such as Oscar Bluemner, Arthur Dove and Max Weber exhibited with Stieglitz and, though it was not their principal medium, expressed themselves in watercolor often enough to become accomplished artists in the technique.

Critic Elizabeth McCausland once said that if one listens to what Stieglitz has to say, "'Free' is the overtone of almost every word. Free to work, free to be himself, free to live without selling his soul."[25] McCausland related this idea to the concept of "Americanness" —it is part of the American soul. She wrote, "Freedom is the right of men, but especially of Americans, because their whole history has been based on this premise."[26] One need only take this a step further to link it to watercolor, because watercolor is often regarded as a free and spontaneous manner of painting. Indeed, McCausland even stated of Marin, O'Keeffe and Dove that "these painters, one believes, are as American as Stieglitz, as truly one with the romantic ebb and flow of American

energies....For the work of these artists (...they aptly symbolize this American sunlight, this American energy), freedom as a way of life is justified."[27]

In addition to this perception of freedom, another feature that linked Marin's and O'Keeffe's as well as Demuth's watercolor work in the teens was an immediacy and expressive quality evident in their images. Marin painted *Weehawken* in 1910 (Cat. No. 33). The candid manner in which he presented the scene as well as the fluidity of the watercolor are similar to the manner in which Demuth painted landscapes in this part of the decade; in fact, Demuth painted a gracefully loose watercolor titled *Landscape after Marin* (fig. 1) in 1914.[28] Marin referred to the expressive quality of his art when he said, "I don't paint rocks, trees, houses, and all things seen. I paint an inner vision...And an inner vision of your own has got to be transposed onto your medium, a picture of that vision."[29] O'Keeffe's watercolors from the teens are replete with organic landscape images done in a freely fluid manner, with the expressive qualities deriving from the loose brushwork as well as the intensity of the watercolor pigment. O'Keeffe identified with the open expanse of the country, and the feeling of infinity which she liked to embrace in her works is conveyed in her abstract as well as her more literal watercolor images.[30] While *Trees and Picket Fence* (fig. 2) focuses upon a definitive image (the trees and the fence), O'Keeffe bordered the image on three sides with blue sky. The vast expansiveness of the sky was as meaningful to her as the objects depicted in her composition.

Although Stieglitz played a major role in the growing acceptance of

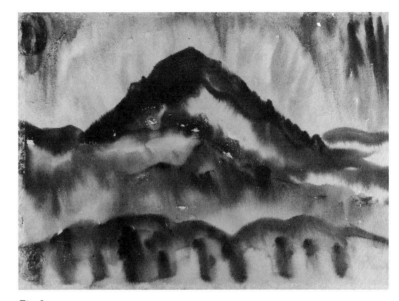

Fig. 1
Charles Demuth (1883-1935)
Landscape after Marin, 1916
Double sided watercolor and pencil on paper
10 1/4 x 14 1/2 inches
Richard York Gallery

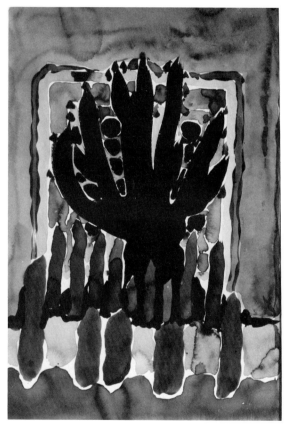

Fig. 2
Georgia O'Keeffe (1887-1986)
Trees and Picket Fence, 1918
Watercolor on paper
18 x 12 inches
Milwaukee Art Museum Collection, Gift of Mrs. Harry Lynde Bradley.

watercolors in the teens, other dealers in New York also exhibited work in the medium and contributed to its increasing popularity. Charles Daniel was a bar owner who began to sell the works of artists who frequented his establishment. Eventually, he opened a gallery and became one of the people most associated with the avant-garde painters in America in the teens and 1920s, especially after 1917 when Stieglitz closed "291." In fact, though he spent much time with the Stieglitz crowd, Demuth was more closely associated with Daniel than Stieglitz in the teens; it was Daniel who gave Demuth his first watercolor exhibition in 1914 and continued to give Demuth one-man watercolor shows until 1919. Daniel was quite cognizant of the exemplary work being done in watercolor, and throughout the teens also showed Preston Dickinson, John Marin and William Zorach in addition to the more traditional artists such as Maurice Prendergast and some of the Ash Can School painters.[31]

The Montross Gallery also showed modern American watercolor painters in the teens. It began by showing the impressionist group The Ten in the late nineteenth century, though The Ten left the Montross Gallery because Newman Montross began to show the younger and more avant-garde twentieth-century American artists in the mid-teens.[32] The Montross Gallery also showed the Cézanne watercolors in 1916. They were far more favorably received in 1916 than five years earlier at Stieglitz's showing, despite the fact that most of the works Montross exhibited were the same as Stieglitz exhibited in his show.[33] The irony of this did not escape Stieglitz, who remarked that

The same water-colors were shown at Montross's some 4-5 years later when duty had been removed from art through the efforts of John Quinn & modern art...At 291 the Cézanne watercolors were on sale for $150-$275—The same water-colors at Montross's were sold at prices three to four times as high to some of the people who had laughed (or perhaps only smiled) at them at 291 four years before.[34]

Montross showed artists such as Demuth as well as those like Burchfield who were not as associated with the avant-garde movement but whose art was, nevertheless, consonant with the spirit of the modern watercolor painters in the early twentieth century.[35] (Whereas Demuth's images embraced the concept of cubism, Burchfield's were more traditionally conservative. The spirit of modernism in Burchfield's work is found in the emotionally symbolic quality of the images.)

Burchfield's watercolors of the teens, like O'Keeffe's work, were distinctly emotional. Burchfield spoke of wanting to live in a dream world of "wildflowers and unseen woods...meeting no other being. I became so oblivious to my surroundings and self that I grew dizzy."[36] *Dream House* (Cat. No. 6) presents a fantasy vision of a cryptic house set within the forest. The sky, which seems to drip with mystery and occupies half of the composition, reinforces the illusionary quality of the image. (The affinity Burchfield felt with nature was characteristic of his works throughout his life, and the emphasis placed upon the sky in this watercolor is a feature which first appeared in his work in 1917.[37])

Discussion of the national character, so prevalent at the time of the Armory Show, continued into the mid-teens. In 1916 James Oppenheim, editor of *The Seven Arts*, characterized the beliefs of the day when he wrote, "It is our faith and the faith of many that we are living in the first days of a renascent period, a time which means for America the coming of that national self-consciousness which is the beginning of greatness."[38]

This newly defined national identification found expression in watercolor, whose qualities could be likened to those of the emerging America. Watercolor is raw, it is spontaneous, it can be full of emotional energy. One scholar said that Marin chose to work in the medium because "it seems likely that he found working in watercolors to have fewer binding traditions, fewer established rules. It proved to be a liberating medium, one with which he was not only comfortable but that enabled him to explore form with a greater sense of abandon."[39] The energy that Marin gave to New York in his watercolors (*Region of Brooklyn Bridge Fantasy* [Cat. No. 38]) and the spirituality that he endowed upon his landscapes (*Lake George, New York* [Cat. No. 29]) show how well suited watercolor is to express intense emotions.

Landscape images have always been prevalent in American painting. America's pristine landscape had been a preferred subject of prominent artists for almost a century and represented the sublimity of nature that embodied the hope of this new country; the portrayal of landscapes had become an American tradition. As such, when artists embraced watercolor as an expression of the American character in the early twentieth

century, it is not surprising that landscape was one image they chose to depict.

Walkowitz's *New York*, 1917 (Cat. No. 50), belongs to the landscape tradition as well—the urban landscape, that is. The vigor of Walkowitz's city is similar to that which Marin endowed upon his New York watercolors. Only a year earlier, one critic wrote about the pulse of New York,

> We were trying to cross the roadway and the block of motors extending from the Forty-Second Street crossing prevented us. Immediately confronting us were the rubber and tires of countless automobiles, and the pistons and valves were shining brightly. Above against the sky could be seen the rectilinear lines of the steel beams of the new office buildings, varied by the zigzags of the derricks and softened here and there by an occasional rope and pulley. This is what you see every day. This is what countless thousands of New Yorkers see every day of their lives. These buzz saws, steel hammers, hard mechanical forms are recorded on your brain. Whether you know it or not they are there. It is impossible not to live incessantly in the midst of such things without being influenced by them.[40]

Walkowitz depicted this city as teeming with vitality, from its massive and anonymous skyscrapers to the multitude of unnamed people below. The ease and zest with which Walkowitz applied watercolor spoke the same language of energy as the newly emerging American character.

The landscape tradition also appears in O'Keeffe's watercolors of the teens (most of O'Keeffe's work done in the teens, an important period for the maturation of modernist painting, was watercolor). Haskell wrote that the most American characteristic of O'Keeffe's watercolors was that they expressed an inner spirituality, using landscape as the vehicle.[41] (Haskell noted that when O'Keeffe abandoned watercolor, her paintings became much more controlled.[42]) The romantic and organic quality of *Untitled* (Cat. No. 36) suggests, though does not explicitly define, the sky with clouds of varying intensities. The image has a dynamic distinction that breathes life, in part because of the fluid properties of the watercolor paint. For O'Keeffe, the organic qualities of watercolor painting worked in accord with the organic demands of her landscape image.

If the public was unaware of O'Keeffe, her talent did not go unnoticed by her peers. Even before he met her, Arthur Dove recognized O'Keeffe's extraordinary talent. Many years later Stieglitz wrote that Dove, after seeing O'Keeffe's watercolors, remarked, "That girl down in Texas does actually what so many of us men are trying to do & can't."[43] O'Keeffe's choice of watercolor as her medium in the teens coincided with the mood of many avant-garde artists in those years. "We were modern," Marguerite Zorach said, "wildly modern—we were drunk with the possibilities of color and form."[44]

Demuth travelled in the same circles as O'Keeffe, and his images, like O'Keeffe's, have become identified with the American character of the early twentieth century. Besides Marin, Demuth is one of the best examples of an important American modernist

who did his most significant work in watercolor. Demuth began painting in watercolor after returning from a trip to Europe in 1914.[45] As if to provide evidence for Zorach's statement about art in the teens, color and form were the essential features of Demuth's work at this time. His talent as a colorist and commitment to watercolor as an expression of mood and emotion become apparent in the floral and landscape images that he chose to paint.[46] His selection of natural forms and landscape imagery was well suited to watercolor because the organic quality of the subject matter was easily expressed using the medium.[47] *Tree Trunks* (fig. 3) is a good example of Demuth's fluid, organic landscape—the trees which sway gracefully in their setting seem alive not only because of the intrinsic suppleness of their character but also because of the manner in which Demuth handled the flowing pigment.

Demuth's work embodied the American character not only in terms of his landscape (and still life) images but in his vaudeville and jazz images as well. "Couldn't we talk about American musical shows, reviews," Demuth wrote, "—the people who act in them…and dance: they really are our 'stuff.' They are our time."[48] Vaudeville was American. *In Vaudeville: Soldier and Girlfriend* (Cat No. 15), with its two figures placed within a theatrical setting, belongs to the series from the teens that Demuth painted of vaudeville performers. The brilliant washes of shimmering color correlate to an ambience of heightened passions, much as one would find in the vaudeville environment.

Jazz, too, was American, and in the teens Demuth also painted a group of images based upon jazz. He frequently visited Barron

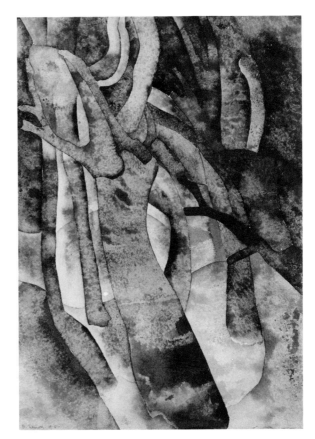

Fig. 3
Charles Demuth (1883-1935)
Tree Trunks, 1916
Double sided watercolor and pencil on paper
14 1/2 x 10 1/4 inches
Richard York Gallery

Wilkin's in Harlem and Marshall's on Fifty-Third Street, both well-known jazz clubs that typify American avant-garde musical establishments from that period.[49] *Negro Jazz Band* (Cat. No. 17), 1916, embodies the steamy milieu of the nightclubs that Demuth frequented. The smoky quality of the pigment as Demuth has applied it evokes the dark, hazy atmosphere of a jazz club, and the juxtaposition of contrasting colors (especially the red and green in the upper left portion of the image) vibrate in a manner that conjures up the tones of music heard in such clubs.

Significantly, when Demuth painted his more abstract work in the teens, it was done in watercolor. *Housetops* (Cat. No. 14), painted in 1918, is typical of the cubist watercolor landscapes that Demuth did. It is a delicate watercolor whose meticulous lines define an image that is at once cubist and realist. Since watercolor is so fluid and therefore difficult to control, the works in this series demonstrate Demuth's exceptional talent in controlling the technical aspects of the medium. The images themselves

characterize Demuth's response to avant-garde abstract art; he would not paint this way in oil until the 1920s.

By the late teens art critics began to recognize the merits of watercolor painting. Hamilton Easter Field evinced this in his review of a watercolor exhibition at the Daniel Gallery in New York.[50] He remarked that individual expression in American painters was beginning to assert itself, and that this exhibition marked a step ahead in American art. Field said that since Homer's death there had been two tendencies in American watercolor, one a rough treatment and the other a more refined approach; Marin exemplified the former and Demuth characterized the latter. "These tendencies," Field wrote, "are each expressive of a side of American life." Notably, Field was writing about general breakthroughs in American art and explaining his point with works done in watercolor. The critics were beginning to notice the merits of watercolor painting.

NOTES

1. Hutchins Hapgood, *New York Globe* (1913) quoted in Marius de Zayas, "How, When, and Why Modern Art Came to New York," *Arts* 54 (April 1980), 106.

2. Stuart Davis had five works in the Armory Show. They were all watercolors. Since Davis, previous to this, was working with Robert Henri, the question of Henri's role in the development of watercolor merits further research. Gratitude is expressed to William C. Agee for his observations on Davis and Henri.

3. Arthur B. Davies, "Chronological Chart," *Arts and Decoration* 3 (March 1913), 178.

4. Annette Blaugrund, "'Sunshine Captured': The Development and Dispersement of Sargent's Watercolors," in Patricia Hills, *John Singer Sargent* (New York: Whitney Museum of American Art, 1987), 225.

5. Helen Appleton Read quoted in "New York Season," *The Art Digest*, 3 (1 February 1929), 15. (Read was not correct regarding the year of the exhibition.)

6. Examples of members of the American Watercolor Society in 1911 were William Glackens, Jerome Myers, Alice Shille and Everett Shinn.

7. "The Value of Water Color Painting and the Spring Exhibition in New York," *The Craftsman* (July 1911), 350. Notably, this statement was written in 1911, the year of the Cézanne exhibition at "291."

8. As will be pointed out later in this essay, a tight approach in watercolor could be successful. This is evident in the work of Charles Demuth and Charles Sheeler.

9. For further information on Paul Cézanne's watercolors see John Rewald, *Paul Cézanne: The Watercolors* (Boston: New York Graphic Society, 1983).

10. John Rewald, "Polemics: Cézanne's First Show in New York," *Cézanne and America* (Washington, D.C.: The National Gallery of Art, 1989), 135.

11. Roger Fry quoted in *Camera Work*, 34-35, (April-July, 1911), 48. This quotation was taken from an article in a "current *Burlington Magazine*" described in the above-mentioned article.

12. Alfred Stieglitz quoted in John Rewald, "Polemics: Cézanne's First Show in New York," *Cézanne and America* (Washington, D.C.: The National Gallery of Art, 1989), 146. The statement first appeared in *Camera Work*.

13. Arthur Hoeber quoted in *Camera Work*, 34-35, (April -July 1911), 48.

14. Alfred Stieglitz to Henry McBride, December 29, 1919, Henry McBride Papers, Roll NMcB12, Archives of American Art, Smithsonian Institution, Washington, D.C.

15. Alfred Stieglitz to Elizabeth McCausland, January 9, 1934, Elizabeth McCausland Papers, Archives of American Art, Smithsonian Institution, Washington, D.C.

16. "Water Colors by Cézanne," *New York Times*, March 12, 1911, quoted in John Rewald, "Polemics: Cézanne's First Show in New York," *Cézanne and America* (Washington, D.C.: The National Gallery of Art, 1989), 148; and *Brooklyn Daily Eagle*, March 8, 1911, quoted in John Rewald, Ibid., 149.

17. John Rewald, Ibid., 151.

18. Marsden Hartley, *Adventures in the Arts*, New York: Boni and Liveright, Inc., 1921 (Reprint: Hacker Art Books, Inc., New York, 1972), 56. Certainly, Hartley was never the same after seeing Cézanne whom he studied with intensity in 1911. (See William Innes Homer, *Alfred Stieglitz and the American Avant-Garde* [Boston: New York Graphic Society, 1977], 154.) Additionally, de Zayas once said that "the exhibitions at '291' of Cézanne and Picasso watercolors and the talks in the gallery stimulated him [Marin] to open up to the suggestion of abstraction as a motive." (Marius de Zayas, "How, When and Why Modern Art Came to New York," *Arts* 54 [April 1980], 116.)

19. Marsden Hartley, *Adventures in the Art*s, New York: Boni and Liveright, Inc., 1921 (Reprint: Hacker Art Books, Inc., New York, 1972), 101.

20. Holger Cahill, *Modern American Watercolors*, exh. cat. (Newark: Newark Museum, 1930), 7.

21. Morgan Russell was an expatriate American painter who moved to Paris in 1909 and remained in Europe (except for two visits to the United States) until 1946. For further information on Russell see Marilyn S. Kushner, *Morgan Russell* (New York: Hudson Hills Press, 1990).

22. Morgan Russell to Andrew Dasburg, October 29, 1910, Andrew Dasburg Papers, Washburn Gallery, New York.

23. Alfred Stieglitz quoted in Barbara Rose, editor, *Readings in American Art* (New York: Holt, Rinehart and Winston, 1975), 45. Original citation taken from "Writings and Conversations of Alfred Stieglitz," Dorothy Norman, ed., *Twice a Year* 14-15 (1947).

24. The first non-photographic exhibition that Stieglitz had at "291" was one of drawings and watercolors by Pamela Colman Smith in January, 1907. The following season (1907-1908), in addition to photography exhibitions, Stieglitz showed drawings by Auguste Rodin, etchings by Willi Geiger and Donald Shaw MacLaughlan, drawings by Pamela Colman Smith, and drawings, lithographs, watercolors, etchings and one oil by Henri Matisse. It was not until the 1908-1909 season that Stieglitz mounted an exhibition that was exclusively oil paintings—from May 8 until May 18 he exhibited oil paintings by Marsden Hartley (although earlier in the season there had been an exhibition of fifteen oil sketches by Alfred Maurer).

25. Elizabeth McCausland, "Stieglitz and the American Tradition," *America & Alfred Stieglitz: A Collective Portrait* (New York: The Literary Guild, 1934), 228.

26. Ibid., 228.

27. Ibid., 229.

28. For a further discussion of Demuth's watercolors in this period see Barbara Haskell, *Charles Demuth* (New York: Whitney Museum of American Art, 1987).

29. John Marin to Alfred Stieglitz, August 14, 1923, in Herbert J. Seligmann, editor, *Letters of John Marin*, (New York: An American Place, 1931), n.p.

30. For further information on O'Keeffe's watercolors, see Barbara Haskell, "Georgia O'Keeffe: Works on Paper, A Critical Essay," in Museum of Fine Arts, Museum of New Mexico, Santa Fe, *Georgia O'Keeffe, Works on Paper* (Santa Fe: Museum of New Mexico, 1985), 1-13.

31. The Ash Can School painters favored painting an urban reality and included William Glackens, Robert Henri, Everett Shinn and John Sloan.

32. Susan Noyes Platt, *Modernism in the 1920s, Interpretations of Modern Art in New York from Expressionism to Constructivism* (Ann Arbor: UMI Research Press, 1985), 24. This book is especially useful for data on dealers and critics in the 1920s.

33. Marius de Zayas, "How, When, and Why Modern Art Came to New York," *Arts* 54 [April 1980], 100.

34. Alfred Stieglitz to Henry McBride, December 29, 1919, Henry McBride Papers, Roll NMcB12, Archives of American Art, Smithsonian Institution, Washington, D.C.

35. Another name that immediately comes to mind when considering active art dealers in the teens is Marius de Zayas, who worked at "291" with Alfred Stieglitz and broke away from him in 1915 so that he could establish a more commercial venture that would support some of Stieglitz's artists. While he was an important dealer in the teens, De Zayas was not instrumental in bringing watercolor painting to the public. De Zayas's Modern Gallery and then the De Zayas Gallery showed many of the modern American painters;

however, from 1915 until 1921 when he returned to Paris, there were only four exhibitions of watercolors, and those were not exclusive watercolor shows. (See Marius de Zayas, "How, When, and Why Modern Art Came to New York," *Arts* 54 [April 1980], 125.) De Zayas was instrumental, however, in helping Stieglitz to arrange the first Picasso exhibition at "291" in April, 1911. It was a show of watercolors and drawings. (See Marius de Zayas, "How, When, and Why Modern Art Came to New York," *Arts* 54 [April 1980], 96.) There were other galleries showing modern art in New York in the teens (the Carroll Galleries and the Washington Square Galleries); however, they did not stress works of art on paper either.

36. Charles Burchfield quoted in John I.H. Bauer, *Charles Burchfield* (New York: The Macmillan Company, 1956), 21. Burchfield wrote this in early 1916.

37. Matthew Baigell, *Charles Burchfield* (New York: Watson-Guptill Publications, 1976), 73. It must be noted here that Burchfield did not exhibit his watercolors with a New York gallery until 1920, when the Kevorkian Gallery mounted a show of his works. (See Munson-Williams-Proctor Institute, *Charles Burchfield* [Utica, New York: Munson-Williams-Proctor Institute, 1970].)

38. James Oppenheim quoted in Sherrye Cohn, *Arthur Dove, Nature as Symbol* (Ann Arbor: UMI Research Press, 1985), 93.

39. Ruth E. Fine, *John Marin* (Washington, D.C., National Gallery of Art, 1990), 80.

40. Anonymous writer, *Sunday Sun*, January 23, 1916, quoted in Marius de Zayas, "How, When, and Why Modern Art Came to New York," *Arts* 54 (April 1980), 108.

41. Barbara Haskell, "Georgia O'Keeffe: Works on Paper, A Critical Essay," in Museum of Fine Arts, Museum of New Mexico, Santa Fe, *Georgia O'Keeffe, Works on Paper* (Santa Fe: Museum of New Mexico, 1985), 11.

42. Ibid., 11.

43. Alfred Stieglitz to Elizabeth McCausland, September 29, 1933, Elizabeth McCausland Papers, Archives of American Art, Smithsonian Institution, Washington, D.C.

44. William Zorach papers, Whitney Museum of American Art, Archives of American Art, Smithsonian Institution, Washington D.C.

45. For further information on Charles Demuth see Barbara Haskell, *Charles Demuth* (New York: Whitney Museum of American Art, 1987).

46. Ibid., 51.

47. While Winslow Homer is a good example of an artist who embraced this combination of landscape and watercolor in the nineteenth century, it was not until the early twentieth century that one finds a consistent number of artists painting landscapes and other natural images in watercolor.

48. Charles Demuth, "'You Must Come Over,' A Painting: A Play," in Barbara Haskell, *Charles Demuth* (New York: Whitney Museum of American Art, 1987), 41.

49. For further information on Charles Demuth, vaudeville and jazz see Barbara Haskell, *Charles Demuth* (New York: Whitney Museum of American Art, 1987), 53-57.

50. Hamilton Easter Field, "Watercolor Exhibits at the Daniel Gallery," A.E. Gallatin Papers, Roll 508, Archives of American Art, Smithsonian Institution, Washington, D.C. This article is dated incorrectly November 7, 1952, since Field died in 1922. Most likely, the review was written in the late teens since Marin (who is mentioned in the review) began showing with Daniel in 1917 when "291" closed, and since it obviously cannot postdate 1922.

FROM WAR TO WAR

It is not coincidental that the period following World War I was a time of rising disenchantment with European art and ideas—politically, America was becoming isolationist.[1] Americans were tired and, with a sense of idealism gone, they turned inward. Whereas before the war many American artists felt that a visit to Europe was essential to their careers, in the 1920s and 1930s many chose to stay in the United States. Even Alfred Stieglitz, who had exhibited many of the avant-garde Europeans' work in the earlier part of the century, in the 1920s elected to show only the work of Americans.[2] As American artists looked to their native country for inspiration, it was logical that some of them embraced watercolor—a medium that was becoming identified as American.

By the late teens/early 1920s, critics began to speak more favorably about watercolor, and artists whose primary work previously had not been in watercolor were painting significant pieces in the medium (Edward Hopper, for example). In 1921 Henry McBride, an influential critic, wrote that one of the most important shows of the season was the Demuth watercolor show at the Daniel Gallery in New York.[3] In that same year he wrote, "We are beating the world in watercolors, just now."[4] He also wrote in 1921 that American art was "beginning to come into her own."[5] McBride recognized the vitality of watercolor painting and the more prominent position it was beginning to take in the role of American art.

In 1921 the Brooklyn Museum mounted "Water Color Paintings by American Artists." Hamilton Easter Field called it "one of the finest water color shows that we have ever had in America," and

went on to say that, as he had frequently pointed out, "watercolor seems to be a medium particularly suited to the American temperament."[6] (Field did not expand upon this statement.) Field knew how to be discriminate and did not favor all watercolor painting—by contrast and in the same season he wrote that the watercolor shows of New York's two major watercolor societies (the American Watercolor Society and the New York City Water Color Club) were very unsuccessful.[7] In a slightly different manner, Paul Strand (a photographer and critic) corroborated Field's opinion of the Brooklyn exhibition by noting that it was "an affirmation that a truly indigenous expression is as possible in America as in Europe."[8] The critics were becoming accustomed to seeing prominent modern American artists working in watercolor and were beginning to accept the medium as meaningful within the broader context of American art.[9] By 1925 John Ward Dunsmore, the president of the American Water Color Society, felt confident enough to say that "it seems certain that a great revival of Water Color [sic] painting is at hand."[10]

Throughout the 1920s and 1930s many artists did compelling work in watercolor. Most of those who had been painting in the medium in the teens, such as Charles Burchfield, Charles Demuth and John Marin, continued to do so (Georgia O'Keeffe is an exception to this—most of her watercolors were painted in the teens, and she did not return to the medium until the 1970s).

While Burchfield and Marin's work did not differ radically from their work of the teens, in the 1920s Demuth's watercolors became tighter, with more reliance upon outline. The latter's watercolors

demonstrated a technical mastery that had first become evident in his cubistic precisionist watercolors of the late teens.[11] Indeed, Demuth referred to the similarity between his work and Marin's when he said, "John Marin and I drew our inspiration from the same sources. He brought his up in buckets and spilled much along the way. I dipped mine out with a teaspoon but I never spilled a drop."[12] *Kiss Me Over the Fence* (Cat. No. 16), one of Demuth's finest works from the 1920s, is a prime example of the work of this decade. The brushwork is controlled and meticulous. While the image has lost the loose freedom visible in Demuth's watercolors from the teens, it has gained a detailed focus resembling that found in Albrecht Dürer's botanical watercolors. Demuth's watercolor images reveal a freshness and wonderment of nature that rank them among the finest of American watercolors.

Marin's watercolor images throughout the 1920s and 1930s continued to portray the vitality of the city or the natural energy of the rural landscape. *Sunset* (Cat. No. 32), a painting once owned by Demuth, belongs to a series of sunset watercolors that Marin painted in the early 1920s. The brilliance of the sun and the light that emanates from it is rendered with an intensity and surety of purpose that serve as testimony to Marin's confidence in handling the medium. The hints of a cityscape that appear in this image and in other images of this series are also apparent in *Region of Brooklyn Bridge Fantasy* (Cat. No. 31), painted ten years later. In addition to the panoramic view of New York and the red-hot sun, this painting includes a horse, which was a recurring image in Marin's work during the period. Critic Ruth Fine described the

horse as "important in all of them [works in this series]…[the horse] seems to stand in the shadow of an emerging America as an icon of an earlier ephemeral world."[13] This dichotomy between the old and the new preoccupied and was depicted by other artists of the period as well. One example of this is Louis Lozowick's 1929 lithograph, *Tanks #1*, in which the central image is a tank that serves as an icon of the importance of the machine in the 1920s. Significantly, two horses appear in the lower right while an airplane flies in the upper left portion of the image.

Other notable artists whose work was not avant-garde began painting important watercolor works in the 1920s—perhaps because they saw that critics had begun to recognize the validity of the medium and realized that artists working principally in watercolor could be respected as important artists. In some cases these artists painted merely a few watercolors and never became known for their work in the medium; in other cases, they painted a significant number of watercolors.

Edward Hopper falls into the latter category—he began painting watercolors in the early 1920s, whereas previously he had worked in oil, doing only minor caricatures in watercolor.[14] Hopper's watercolors proved to be quite popular, more so than his former oil paintings. In fact, *The Mansard Roof*, the watercolor Hopper sold to the Brooklyn Museum in 1923, was the first painting he had sold in ten years, and his exhibition of eleven watercolors at the Frank K. M. Rehn Gallery sold out completely.[15] The critical success of this exhibition gave Hopper the self-assurance to continue producing in watercolor. *Light at Two Lights*, 1927, (fig.

4) is one of six images of a lighthouse near Cape Elizabeth, Maine. In that series, three works were watercolors, two were oils and one was a drawing. Not only did he choose not to paint all of these works in oil, but the watercolors are not sketchy studies for the larger oils; they are finished works of art meant to stand alone. Not all of Hopper's watercolor images were as conventional as his lighthouses—*Corn Hill* and *Adobe Houses* (Cat. No. 26, 27) are examples of less traditional compositions. Hopper's decision to work in watercolor in the 1920s when he had previously painted mostly in oil was likely due to the greater acceptance of watercolor that was emerging in the 1920s and 1930s. Hopper obviously felt that he might find success in the medium, and once he did so with the 1923 exhibition, he continued to work in watercolor.

Charles Sheeler's watercolors are seldom singled out for mention (possibly because he did not paint many of them), yet they deserve attention for their excellence. Because he was a photographer, Sheeler was sensitive to the special qualities of works on paper, which doubtless helped him excel in watercolor despite his lack of experience in the medium. Like photography, which grapples with the dilemma of representing a depth field on a flat surface, watercolor painting, by virtue of the translucent paints, cannot deny the paper surface nearly as easily as can oil painting. Sheeler's images do not reveal the immediacy or energy evident in the work of so many other American masters of watercolor in the twentieth century. Rather, his watercolors display a controlled temperance reminiscent of Demuth's contained precisionist works of the teens. Sheeler's emphasis on the planar aspects of the

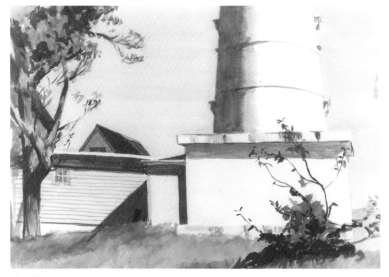

Fig. 4
Edward Hopper (1882-1967)
Light at Two Lights, 1927
Watercolor on paper
13-15/16 x 19-15/16 inches
Collection Whitney Museum of American Art. Josephine N. Hopper Bequest. 70.1143.

buildings in both *Bucks County Barn* and *Study for Classic Landscape* (Cat. No. 43, 45) (and in the vast majority of his structures) is in harmony with the flat surface of the white ground that Sheeler does not deny.

Preston Dickinson, a New York artist who lived in Paris from 1915 until 1919, was another who painted a number of significant works in watercolor during the 1920s and 1930s. Reportedly, Dickinson's art, especially the landscapes, was considerably affected by the Cézannes that he saw at the Armory Show (although Dickinson certainly could have seen Cézanne's works anywhere, especially during his tenure in Paris).[16] The very Cézanesque *The Black House* (Cat. No. 19) is a work that confirms this influence. This painting depicts a group of houses (with a black house in the center) painted in a manner that emphasizes the planar features of the structures. The image is especially suited to watercolor because, like Cézanne, Dickinson effectively employed the white paper ground as a device against which to set the scene as well as a tool to emphasize the planarity of the composition. The mountains in the background bear a strong resemblance to Cézanne's familiar images of Mt. St. Victoire.

Although he was born in Italy, Joseph Stella spent most of his productive years in the United States and is considered an American artist. Jaffe commented that "the combination of observation and aspiration, literalness and interpretation, brashness and delicacy, that seems so typically American is one of the most characteristic qualities in Stella's art."[17] Certainly, this is a legitimate characterization of the artist. However, there is a more important aspect of Stella's art that calls for his inclusion in a discussion of American watercolor: he craved freedom. "The first need of an artist," he wrote, "is absolute freedom, freedom from schools, from critics, advisors and the so-called friends…The audience should not exist while the work of art is done. Birds sing to pour out their joy of living."[18] As has been established, the techniques of watercolor speak of freedom and immediacy. While some of Stella's images do not necessarily embody a perception of release (*Study for The Little Lake*, for example), other works contain the rawness and spontaneity that *is* associated with watercolor and American art. *Abstraction: Red and Black* contains not only the feeling of powerful energy but is also direct and brash—it is confrontational in both its imagery and the bold use of color which is present in so many of Stella's watercolors. *Study for "The Little Lake"* and *Geometric Abstraction* (Cat. No. 47, 48), while they do not contain these characteristics, are individually spiritual works. They have an emotional quality that transcends preoccupation with mundane reality. Stella once commented that on many nights when he stood alone on the Brooklyn Bridge he became "deeply moved, as if on the threshold of a new religion or in the presence of a new DIVINITY."[19] The personal spirituality of his watercolors, while stylistically very different, can be likened to O'Keeffe's watercolors from the teens, which contained a similar emphasis on ethereal passions.[20]

The Newark Museum, an institution that had always been supportive of watercolors, mounted an American watercolor exhibition in January/February 1930. In his introduction to the

catalogue, Holger Cahill wrote that "there has been a definite revival of the art of the watercolor. In America, the medium has attracted some of our best artists."[21] This "revival," which had actually commenced ten years earlier, was fully evident by the early 1930s. Cahill also remarked that while there was not a singular school of watercolor painting (most artists were working independently), these painters had reached new heights in the medium and had opened it up to a profusion of new possibilities.[22]

Sherman Lee also commented upon a rekindling of attention to watercolor in the 1930s, which he linked to a rising nationalism in the United States.[23] This concept is analogous to the previously mentioned theory that one reason for the initial rise of interest in watercolor in the teens was the "Americanness" of the medium and its aptness for rendering an American imagery. Lee also linked the importance of watercolor in the 1930s with the expansion of schools and teaching of the medium in that decade as well as with the requisites of commercial art, which required preliminary sketches that were often done in watercolor.[24]

As Cahill wrote in his 1930 exhibition catalogue, the artists painting watercolors in the 1930s crossed all boundaries. Some were doing abstract work; others explored different techniques. For example, Hopper did representational work; Arthur Dove worked in a non-representational manner. Dove began painting watercolors in the early 1930s. His works were not as technically adept as Demuth or Marin's, yet his watercolor paintings deserve attention in any discussion of American watercolors because of their affinity with nature and landscape. Once he began painting

in watercolor, Dove did a substantial number of works in the medium. Although many of his oil paintings derive from watercolors painted in the 1930s, it cannot be proven that Dove considered watercolors works of "lesser status" that were only intended as studies.[25] This was a moment when watercolors enjoyed enormous popularity, and it is possible that Dove turned to them because, at least in certain instances, he preferred watercolor's properties and capabilities to oil. Many of Dove's watercolors are images of the rural landscape that he knew so well. *Barges* (Cat. No. 21), a river scene, conveys Dove's spiritual integration with the waterways as well as his closeness to nature and the landscape. In this he is distinctly American. His images are depicted with freshness and innocent simplicity.

As mentioned previously, the city was as American a subject as the rural farms. One example of an artist who explored cityscapes as an American watercolor subject is George Grosz. Grosz painted *Broadway* in 1934 (Cat. No. 25). While his work is not abstract, neither is it purely representational, and as such it stands between Hopper's more realistic images and Dove's abstract work. The excitement of Broadway and the free energy expended in the application of watercolor merge in this composition, producing an image that radiates the verve of the city and resembles Walkowitz's and Marin's earlier images of New York.

The popularity of watercolor continued through the 1930s. In 1936 a writer for *Art Digest* reviewed the watercolor exhibition at the Art Institute of Chicago, stating "water color has been enjoying a position of ever increasing importance in American art during

the past few years."[26] The popularity of watercolors did not immediately translate into their commanding a full share of the art market, however. In 1939 the Macbeth Gallery stated that a "good deal of the best work that is being produced by American artists today is being done in the water color medium, and yet, as far as the public is concerned, water color is the most neglected of all mediums."[27] Quite possibly, this comment stems from the fact that the public was not purchasing watercolors during the 1930s, despite their ever-increasing popularity among artists and critics. Sales for the American Watercolor Society Exhibition, for example, dropped enormously between 1926 and 1934. In 1926, thirty-seven paintings were sold at the annual exhibition; the number tapered off to four by 1934.[28] However, it is likely that the nation's severely depressed economy was the reason for this, rather than lack of acceptance of the medium. Indeed, watercolor had achieved plenty of critical acclaim during the decade.

In the late 1930's James Daugherty painted *Contemporary Literature* (Cat. No. 9). While some of Daugherty's watercolors were studies for larger murals, this one was not.[29] Rather, this is a completed work that is quite intricate. The image contains those individuals whom Daugherty felt best told the story of twentieth-century literature. Gertrude Stein sits in the lower right of the composition while Carl Sandberg is on the left. In the center of the image stands a family representing the American scene or art of the 1930s. They are surrounded by a halo which recalls Daugherty's (and other artists') abstract works from the teens. The painting is actually about the arts in the twentieth century. The fact that Daugherty chose to make such an important statement about his art in watercolor testifies to the level of success and respect that watercolors had finally achieved.

American attitudes towards watercolor had come a long way since 1911, when the Cézanne watercolor exhibition at "291" was ignored or disparaged and the medium had to fight for acceptance. While artists had worked in watercolor for centuries, it was not until the early twentieth century that prominent American artists began to paint some of their major works in watercolor, paving the way for others to follow in the 1920s and 1930s. Additionally, it is not a fluke that this occurred simultaneously with an era of American history that sought to clarify the exact nature of the emerging nation's character. The opinions of the major artists, dealers and eventually critics converged at a time in America's history that produced this surge of interest in watercolor. The result was that by the onset of World War II, watercolor was fully accepted by significant American artists and the American public as an important medium in its own right.[30]

NOTES

1. For further discussion of this period see Patrick Stewart and Gilbert Vincent, "Changing Patterns in the Avant-Garde: 1917-1925," in *Avant-Garde Painting & Sculpture in America 1910-25*, exh. cat. (Newark, Delaware Art Museum, 1975), 27-28.

2. See Sherrye Cohn, *Arthur Dove: Nature as Symbol*, (Ann Arbor, Michigan, UMI Research Press, 1985), 98. The Americans whose work Stieglitz decided to showcase were Charles Demuth, Arthur Dove, Marsden Hartley, John Marin, Georgia O'Keeffe, Paul Strand and himself.

3. Henry McBride, "Modern Art," *The Dial* 40 (January 1921), 1921, 235.

4. Henry McBride, *The Dial*, May, 1921 found in Henry McBride Papers, Roll NMcB11, Archives of American Art, Smithsonian Institution, Washington, D.C.

5. Henry McBride, "Modern Art," *The Dial* 40 (January 1921), 112.

6. Hamilton Easter Field, "Comment on the Arts," *The Arts* 2 (November 1921), 112.

7. Hamilton Easter Field, "Comment on the Arts," *The Arts* 2 (December 1921), 176. The membership in these watercolor societies consisted of lesser-known, more conservative artists. None of the Stieglitz artists and few acknowledged modernist painters were members throughout the 1920s and 1930s. Members included Gifford Beal, Edward Penfield, Edward Potthast and W. Granville-Smith. Joseph Pennell was elected a member of the American Water Color Society in 1922 but refused the membership. In 1925 Martin Lewis was elected into the society. For further information on the American Watercolor Society, see the American Watercolor Society Papers, Archives of American Art, Smithsonian Institution, Washington, D.C., and Ralph Fabri, *History of the American Watercolor Society: The First Hundred Years* (USA, American Watercolor Society, 1969).

8. Paul Strand, "American Watercolors at the Brooklyn Museum," *The Arts* 2 (January 20, 1922), 151.

9. This point merits further research and may reveal previously overlooked information about American attitudes towards all works of art on paper in the teens and 1920s.

10. American Water Color Society President's Report, 1925, American Water Color Society Papers, Archives of American Art, Smithsonian Institution, Washington, D.C., roll N68-69.

11. Burchfield's style would change, but his transition to a more pronounced realism did not occur until the early 1930s.

12. Quoted in George Biddle, *An American Artist's Story* (Boston: Little, Brown & Company, 1939), 216.

13. Ruth Fine, *John Marin* (New York: Abbeville Press, 1990), 131.

14. I would like to thank Deborah Lyons, Advisor, Hopper Collection, Whitney Museum of American Art, New York, for her insights into Edward Hopper.

15. Gail Levin, *Edward Hopper, The Art and the Artist* (New York: W.W. Norton & Company, 1980), 37. Frank Rehn carried the more traditional artists. In addition to Hopper, he also sold works by Burchfield.

16. The Columbus Gallery of Fine Arts, *American Paintings in the Ferdinand Howald Collection* (Columbus: Columbus Gallery of Fine Arts, 1969), 34. There was only one Cézanne watercolor in the Armory Show—therefore any influences of Cézanne watercolors upon Dickinson were probably not from what he saw then.

17. Irma B. Jaffe, *Joseph Stella* (Cambridge: Harvard University Press, 1970), 132.

18. Joseph Stella, "Jottings," c. 1919, quoted in John I.H. Baur, *Joseph Stella* (New York: Praeger Publishers, 1971), 39.

19. Joann Moser, "Visual poetry: The drawings of Joseph Stella," *Antiques* 138 (November 1990), 1069.

20. For further information on Stella's watercolors see Joanne Moser, *Visual Poetry: The Drawings of Joseph Stella* (Washington, D.C.: Smithsonian Institution Press, 1990).

21. Holger Cahill, *Modern American Watercolors*, exh. cat. (Newark, New Jersey: The Newark Museum, 1930), 7.

22. Ibid., 7.

23. Sherman E. Lee, "A Critical Survey of American Watercolor Painting," (Ph.D. diss., Western Reserve University, 1941), 310.

24. Sherman E. Lee, "A Critical Survey of American Watercolor Painting," (Ph.D. diss., Western Reserve University, 1941), 310. This point is intriguing and merits further study—especially of the role the schools played in the development of watercolor painting.

25. This is what Morgan claimed in her catalogue raisonné of Dove's works. See Ann Lee Morgan, *Arthur Dove, Life and Work, With a Catalogue Raisonné* (Newark: University of Delaware Press, 1984), 87.

26. N.S., "519 Water Colors, 125 From Abroad, in Chicago's International," *Art Digest*, 15 March 1936, 15.

27. N.S., *American Watercolors, Past and Present*, exh. cat., (New York: Macbeth Gallery, 1939), n.p.

28. Frank Gervasi, "History of the American Watercolor Society," p. 63, in American Watercolor Society Papers, Archives of American Art, Smithsonian Institution, Washington, D.C. Similarly, prints were not selling between 1930 and 1934 either. Gratitude is expressed to Sylvan Cole for his observations on the topic in a conversation with the author, December 17, 1990.

29. This information was given to the author in a conversation with the artist's son, Charles Daugherty, on April 20, 1990.

30. For a study of abstract expressionist watercolors see Jeffrey Wechsler, "Notes on the Application of Watercolor and Related Mediums to the Abstract Expressionist Aesthetic," in *Watercolors from the Abstract Expressionist Era*, exh. cat. (Katonaha, New York: The Katonah Museum of Art, 1990), n.p.

ANNOTATED CHECKLIST

1.

Anonymous
City of the Future, ca. 1915-20
Watercolor on paperboard, 12 3/4 x 11 15/16 inches
Arthur J. Phelan, Jr. Collection

> Provenance: Robert Paul Weimann III

2.

Oscar Bluemner (1892-1938)
Harmony in Scarlet, 1925
Watercolor on paper, 9 1/2 x 12 3/4 inches
Mr. and Mrs. W. John Driscoll

> Provenance: Aline Meyer Liebman; her daughter

> Selected Bibliography: *An American Gallery, Vol. VI*, Richard York Gallery, New York, 1990, no. 29.

3.

Oscar Bluemner
Hillside, New Jersey, 1929
Watercolor on paper, 5 x 6 3/4 inches
Private collection

> Provenance: Irma Rudin Fine Arts

> Selected Bibliography: *Oscar Bluemner: Works on Paper*, Linda Hyman Fine Arts, New York, 1988, no. 69.

4.

Oscar Bluemner
Moon Radiance, 1927
Watercolor on paper, 9 1/2 x 12 inches
Private collection

> Provenance: Graham Gallery

> Selected Bibliography: *The Natural Image: Plant Forms in American Modernism*, Richard York Gallery, New York, 1982, "Introduction" (n.p.), no. 2.

5.

Oscar Bluemner
Sketch for "Port Mystic," Connecticut, 1930
Watercolor on paper, 4 1/4 x 5 1/2 inches
Private collection

> Provenance: Irma Rudin Fine Arts

> Selected Bibliography: *Oscar Bluemner: Works on Paper*, Linda Hyman Fine Arts, New York, 1988, no. 69.

6.

Charles E. Burchfield (1893-1967)
Dream House, ca. 1917
Watercolor on paper, 17 1/2 x 21 3/4 inches
Kennedy Galleries, Inc., New York

> Provenance: Estate of the artist

7.

Charles E. Burchfield

The Insect Chorus, 1912

Opaque and transparent watercolor with ink and crayon on paper, 19 7/8 x 15 7/8 inches

Munson-Williams-Proctor Institute Museum of Art, Utica, New York. Edward W. Root bequest

> Provenance: Frank Rehn Gallery; Edward W. Root
>
> Selected Bibliography: *Charles Burchfield: Early Watercolors 1916 to 1918*, Museum of Modern Art, New York, 1930, p. 11, no. 15. *Paintings by Charles Burchfield*, Edward W. Root Art Center, Hamilton College, Clinton, New York, 1962, "Note on the Exhibition" (n.p.). Baur, John I. H., *Life and Work of Charles Burchfield, 1893-1967*, University of Delaware Press, Newark, 1984, p. 70. Finch, Christopher, *American Watercolors*, Abbeville Press, New York, 1986, p. 218.

8.

Charles E. Burchfield

Night Scene, 1935

Watercolor on paper, 16 1/8 x 26 1/4 inches

Collection of Whitney Museum of American Art; gift of Charles Simon 77.117

> Provenance: Charles Simon
> Selected Bibliography: Sims, Patterson, *Charles*

Burchfield: A Concentration of Works from the Permanent Collection of the Whitney Museum of American Art, Whitney Museum of American Art, 1980, p. 19. Baur, John I. H., *Life and Work of Charles Burchfield, 1893-1967*, University of Delaware Press, Newark, 1984, p. 182. Finch, Christopher, *Twentieth-Century Watercolors*, Abbeville Press, New York, 1988, p. 215.

9.

James Daugherty (1889-1974)

Contemporary American Literature (Study for "American Life in Literature" published by Harper Brothers, 1949), late 1930s

Watercolor on paper, 23 x 29 inches

The Montclair Art Museum, New Jersey; gift of Mr. and Mrs. Jerome Shelby, S. Barksdale Penick Fund, William Lightfoot Schultz Fund, Mrs. Sigfried Peierls, Mrs. Henry Lang and anonymous by exchange

> Provenance: Charles Daugherty; Salander O'Reilly Gallery

10.

Arthur B. Davies (1862-1928)

Untitled, 1924

Watercolor on paper, 9 1/8 x 12 1/4 inches

The Montclair Art Museum, New Jersey; gift of Dr. and Mrs. Milton Luria

11.
Stuart Davis (1894-1964)
Gas Pumps, 1925
Watercolor on paper, 14 1/2 x 12 1/2 inches
Rose Art Museum, Brandeis University, Waltham, Massachusetts;
gift of Mrs. Teresa Jackson Weill

Provenance: Mrs. Teresa Jackson Weill

Selected Bibliography: *The Teresa Jackson Weill Collection of Art*, Rose Art Museum, Brandeis University, Waltham, Massachusetts., 1980, p. 34, no. 28. Agee, William C. and Robert Hunter, *Stuart Davis: A Catalogue Raisonné*, Yale University Press, New Haven (forthcoming).

12.
Stuart Davis
Lakefront, 1917
Watercolor and pencil on paper, 12 x 15 inches
The Montclair Art Museum, New Jersey. Museum purchase, Lang Acquisition Fund

Provenance: Von Drejcin Galleries

Selected Bibliography: Agee, William C. and Robert Hunter, *Stuart Davis: A Catalogue Raisonné*, Yale University Press, New Haven (forthcoming).

13.
Stuart Davis

Windshield, 1931
Gouache on paper, 12 x 17 inches
Mrs. Volney W. Foster

Provenance: Downtown Gallery

Selected Bibliography: Agee, William C. and Robert Hunter, *Stuart Davis: A Catalogue Raisonné*, Yale University Press, New Haven (forthcoming).

14.
Charles Demuth (1883-1935)
Housetops, 1918
Watercolor on paper, 9 3/4 x 13 1/2 inches
Columbus Museum of Art, Ohio; gift of Ferdinand Howald

Provenance: Daniel Gallery; Ferdinand Howald

Selected Bibliography: Tucker, Marcia, *American Paintings in the Ferdinand Howald Collection*, Columbus Gallery of Fine Arts, Ohio, 1969, p. 22, no. 24

15.
Charles Demuth
In Vaudeville: Soldier and Girlfriend, 1915
Watercolor on paper, 10 3/4 x 8 1/4 inches
Private collection

Provenance: Hirschl & Adler Galleries

Selected Bibliography: Haskell, Barbara, *Charles Demuth*, Whitney Museum of American Art, New York,

1987, p. 53.

16.
Charles Demuth
Kiss Me Over the Fence, 1929
Watercolor on paper, 11 5/8 x 17 1/2 inches
Private collection

Provenance: Durlacher Brothers; Mr. and Mrs. Lawrence A. Fleishman

Selected Bibliography: Eiseman, Alvord L., *Charles Demuth*, Watson-Guptill Publications, New York, 1982, p. 21. Helen A. Cooper, "The Watercolor of Charles Demuth," *Antiques Magazine*, 133 (January 1988), p. 265.

17.
Charles Demuth
Negro Jazz Band, 1916
Watercolor on paper, 12 7/8 x 7 7/8 inches
Collection of Irwin Goldstein, MD, Wayne, New Jersey

18.
Charles Demuth
Zinnias, 1926
Watercolor and pencil on paper, 13 1/2 x 19 1/4 inches
Gerald Peters Gallery, Santa Fe, New Mexico and Hirschl & Adler Galleries, New York

Provenance: The artist; by descent to Robert Locher, New York and Lancaster, Pennsylvania, 1935; Kraushaar

Galleries, New York; George D. Dyer, Norfolk, Connecticut, 1937; by descent through his family

Selected Bibliography: Farnham, Emily, *Charles Demuth: His Life, Psychology, and Works* (PhD dissertation, The Ohio State University, 1959), vol. II, no. 497, p. 608.

19.
Preston Dickinson (1891-1930)
The Black House, ca. 1923
Watercolor and pastel on paper, 16 1/2 x 10 3/4 inches
Columbus Museum of Art, Ohio; gift of Ferdinand Howald

Provenance: Daniel Gallery; Ferdinand Howald

Selected Bibliography: Cloudman, Ruth, *Preston Dickinson, 1889-1930*, Sheldon Memorial Art Gallery, Lincoln, Nebraska, 1979, pp. 23, 25, 86.

20.
Preston Dickinson
Locomotive, 1922
Watercolor on paper, 9 7/8 x 12 inches
Arthur J. Phelan, Jr. Collection

21.
Arthur Garfield Dove (1880-1946)
Barges, 1934
Watercolor on paper, 10 x 10 inches
Baker/Pisano Collection

Provenance: Estate of the artist; Terry Dintenfass, Inc.

Selected Bibliography: *Late Nineteenth Century and Early Modernist American Art: Selections from the Baker/Pisano Collection*, Heckscher Museum, Huntington, New York, 1983, p. 45.

22.
Arthur Garfield Dove
Dawn III, 1932
Watercolor on paper, 15 1/16 x 15 9/16 inches (sheet); 9 9/16 x 9 9/16 inches (image)
The Brooklyn Museum; Dick S. Ramsay Fund 55.22

Provenance: Downtown Gallery

Selected Bibliography: Finch, Christopher, *American Watercolors*, Abbeville Press, New York, 1986, p. 202.

23.
Arthur Garfield Dove
From an Orchard, 1938
Watercolor on paper, 5 x 7 inches
Collection of Elizabeth Moore

Provenance: Alfred Stieglitz, Downtown Gallery; Terry Dintenfass Gallery

24.
Arthur Garfield Dove
Gasoline Tanks, 1932

Watercolor and metallic paint on paper, 5 x 7 inches
Private collection

Provenance: Downtown Gallery

25.
George Grosz (1893-1959)
Broadway, 1934
Watercolor on paper, 26 1/4 x 19 inches
Anonymous lender

Provenance: David Findlay Gallery

Selected Bibliography: *The Walbridge Legacy*, San Diego Museum of Art, San Diego, 1988, p. 59.

26.
Edward Hopper (1882-1967)
Adobe Houses, 1925
Watercolor on paper, 13 5/8 x 19 5/8 inches
Private collection

Provenance: Kennedy Galleries, Inc.

Selected Bibliography: Levin, Gail, *Edward Hopper: A Catalogue Raisonné*, Whitney Museum of American Art, New York, in association with W. W. Norton, New York (forthcoming).

27.
Edward Hopper
Corn Hill, ca. 1930
Watercolor on paper, 14 x 20 inches
Courtesy of Shearson Lehman Brothers.

Provenance: Hirschl & Adler Galleries

Selected Bibliography: Levin, Gail, *Edward Hopper: A Catalogue Raisonné*, Whitney Museum of American Art, New York, in association with W. W. Norton, New York (forthcoming).

28.
John Marin (1870-1953)
Brooklyn Bridge, on the Bridge, 1930
Watercolor on paper, 21 3/4 x 26 3/4 inches
Daniel J. Terra Collection, Terra Museum of American Art, Chicago

Provenance: John Marin Family; Kennedy Galleries, Inc.

Selected Bibliography: Fine, Ruth E., *John Marin*, National Gallery of Art and Abbeville Press, 1990, p. 134.

29.
John Marin
Lake George, New York, 1928
Watercolor on paper, 13 x 16 1/2 inches
Kennedy Galleries, Inc., New York

Provenance: Mr. and Mrs. John Marin, Jr.

30.
John Marin
Off Norton Island, Maine Coast, 1933
Watercolor on paper, 15 1/4 x 21 1/2 inches
The Montclair Art Museum, New Jersey; gift of Mr. and Mrs. H. St. John Webb

Provenance: Downtown Gallery

Selected Bibliography: Reich, Sheldon, *John Marin: A Stylistic Analysis and Catalogue Raisonné*, University of Arizona Press, 1970, vol. II, p. 656, no. 33.20.

31.
John Marin
Region of Brooklyn Bridge Fantasy, 1932
Watercolor on paper, 18 3/4 x 22 1/4 inches
Collection of Whitney Museum of American Art; purchase 49.8.

Provenance: An American Place Gallery

Selected Bibliography: *John Marin in Retrospect: An Exhibition of His Oils and Watercolors*, Corcoran Gallery of Art, Washington, and Currier Gallery of Art, Manchester, New Hampshire, 1962, p. 13. Reich, Sheldon, *John Marin: A Stylistic Analysis and Catalogue Raisonné*, University of Arizona Press, 1970, vol. II, p. 648, no. 32.37. Cummings, Paul, *Twentieth-Century Drawings from the Whitney Museum of American Art*, Dover Publications, New York, 1981, p. 115, no. 27.

32.
John Marin
Sunset, 1922
Watercolor, graphite, and charcoal on paper, 17 1/2 x 21 1/2 inches
Eleanor and Tom May

> Provenance: Charles Demuth; A. Kraushaar; Edith Gregor Halpert; Kennedy Galleries

> Selected Bibliography: *The May Family Collection of American Paintings*, Hunstville Museum of Art, Hunstville, Alabama, and the Lotus Club, New York, 1988, p. 41. Fine, Ruth E., *John Marin*, National Gallery of Art, Washington, 1990, p. 191.

33.
John Marin
Weehawken, New Jersey, 1910
Watercolor over pencil on heavy off-white wove paper, 13 7/8 x 14 7/8 inches
Courtesy of the Pennsylvania Academy of the Fine Arts, Philadelphia; gift of James P. and Ruth M. Magill

> Provenance: James P. and Ruth M. Magill

34.
Georgia O'Keeffe (1887-1986)
Chicken in Sunrise, 1917
Watercolor on paper, 11 7/8 x 8 7/8 inches

Milwaukee Art Museum; gift of Mrs. Harry Lynde Bradley

> Provenance: Downtown Gallery, Mrs. Harry Lynde Bradley

35.
Georgia O'Keeffe
Untitled, 1917
Watercolor on paper, 12 x 8 7/8 inches
Collection of Françoise and Harvey Rambach

> Provenance: Paul Strand; Joan Washburn Gallery

36.
Georgia O'Keeffe
Untitled, 1917
Watercolor on paper, 12 x 8 7/8 inches
Michael Scharf Collection

> Provenance: Ahmet Ertegun Collection

37.
Georgia O'Keeffe
Untitled, 1917
Watercolor on paper, 12 x 8 7/8 inches
Michael Scharf Collection

> Provenance: Ahmet Ertegun Collection

38.
Walter Pach (1883-1958)
Untitled, 1914
Watercolor on illustration board, 14 1/2 x 10 1/2 inches
Collection of Whitney Museum of American Art; gift of Francis
Steegmuller in memory of Gerda and Beatrice Stein; 85.22

> Provenance: Mrs. Gerda Stein; Mr. and Mrs. Francis
> Steegmuller; Francis Steegmuller

39.
Morgan Russell (1886-1953)
Color Study, 1912-13
Watercolor on paper, 5 3/4 x 3 3/4 inches
Morgan Russell Archives, The Montclair Art Museum, New Jersey

> Provenance: Louis Sol; Roy Garber; Henry Reed

40.
Morgan Russell
Still Life, ca. 1915
Watercolor on paper, 5 3/4 x 8 3/8 inches
The Montclair Art Museum, New Jersey; gift of Mr. and Mrs.
Henry M. Reed

> Provenance: Louis Sol; Roy Garber; Henry Reed

41.
Morgan Russell
Study after Michelangelo's "Pietà," 1912
Watercolor and pencil on paper, 12 x 6 1/2 inches

Morgan Russell Archives, The Montclair Art Museum, New Jersey

> Provenance: Louis Sol; Roy Garber; Henry Reed

> Selected Bibliography: Levin, Gail, *Synchronism and
> American Color Abstraction, 1910-1925*, George Braziller,
> New York, in association with the Whitney Museum of
> American Art, 1978, p. 17. Kushner, Marilyn S., *Morgan
> Russell*, Hudson Hills Press, New York, in association
> with Montclair Art Museum, 1990, pp. 83, 87.

42.
Morton Livingston Schamberg (1882-1918)
Composition, 1916
Watercolor and graphite on paper, 11 1/2 x 9 1/2 inches
Columbus Museum of Art, Ohio; gift of Ferdinand Howald

> Provenance: Ferdinand Howald

> Selected Bibliography: Wolf, Ben, *Morton Livingston
> Schamberg*, University of Pennsylvania, Philadelphia,
> 1963, p. 52, no. 43. Tucker, Marcia, *American Paintings
> in the Ferdinand Howald Collection*, Columbus Gallery of
> Fine Arts, Ohio, 1969, p. 95, no. 154.

43.
Charles Sheeler (1883-1965)
Bucks County Barn, 1926
Watercolor over pencil on paper, drymounted on illustration
board, 8 x 10 3/16 inches
San Diego Museum of Art; bequest of Earle W. Grant

Provenance: Downtown Gallery; Earle W. Grant

Selected Bibliography: Troyen, Carol, and Erica E. Hirshler, *Charles Sheeler: Paintings and Drawings*, Little Brown and Company, Boston, 1987, p. 140, footnote 2.

44.
Charles Sheeler
River Rouge Industrial Plant, 1928
Graphite and watercolor on paper mounted on paper, 8 3/8 x 11 1/4 inches
The Carnegie Museum of Art, Pittsburgh; gift of G. David Thompson, 1957

Provenance: G. David Thompson.

Selected Bibliography: *The Rouge: The Image of Industry in the Art of Charles Sheeler*, Detroit Institute of Arts, Michigan, 1978, pp. 9, 15, 32, no. 23. *American Drawings and Watercolors in the Museum of Art, Carnegie Institute*, Museum of Art, Carnegie Institute, 1985, pp. 166, 300, no. 387. Troyen, Carol, and Erica E. Hirshler, *Charles Sheeler: Paintings and Drawings*, Little, Brown and Company, Boston, 1987, p. 120.

45.
Charles Sheeler
Study for Classic Landscape, 1920s
Watercolor on paper, 3 1/2 x 4 1/2 inches
Edsel and Eleanor Ford House, Grosse Point Shores, Michigan

Provenance: Gift of the artist to Otto Spaeth; Mrs. Otto Spaeth; Sotheby's

46.
Joseph Stella (1879-1946)
Abstraction: Red and Black, nd
Watercolor on paper, 12 15/16 x 11 3/4 inches
Pensler Galleries, Washington, D.C.

47.
Joseph Stella
Geometric Abstraction, ca. 1916
Watercolor on paper, 13 13/16 x 9 5/8 inches
Collection of Robert and Anna Steiner

Provenance: Pensler Galleries

48.
Joseph Stella
Study for "The Little Lake," 1926
Watercolor on paper, 9 1/2 x 7 1/2 inches
The Montclair Art Museum, New Jersey; gift of Mr. Bernard Rabin

Provenance: Bernard Rabin

49.
John von Wicht (1888-1970)
Untitled, 1937
Watercolor on paper, 10 5/8 x 12 inches

D. Bradley and R. Blacher

 Provenance: Martin Diamond Fine Arts

50.
Abraham Walkowitz (1880-1965)
New York, 1917
Watercolor, ink and pencil on paper, 30 5/8 x 21 3/4 inches
Collection of Whitney Museum of American Art; gift of the artist in memory of Juliana Force; 51.35

 Provenance: Gift of the artist

51.
Abraham Walkowitz
Untitled, 1914
Watercolor on paper, 24 1/4 x 19 inches
Michael Scharf Collection

 Provenance: Sid Deutsch Gallery; Ahmet Ertegun Collection

52.
Max Weber (1881-1961)
Still Life with Daisy, Bottle and Peach, 1911
Watercolor on paper, 9 x 6 inches
Arthur J. Phelan, Jr. Collection

 Provenance: Reed Harris Estate; Weschler's Auctioneers

53.
Max Weber
Study for Russian Ballet, 1914
Watercolor on paper, 18 1/2 x 24 1/2 inches
The Brooklyn Museum; gift of the Edith and Milton Lowenthal Foundation; 88.205

 Provenance: Edith and Milton Lowenthal.

 Selected Bibliography: *Modernist Art from the Edith and Milton Lowenthal Collection*, Brooklyn Museum, New York, 1981, p. 54, no. 62.

54.
William Zorach (1887-1966)
In the Sierras, 1920
Watercolor on paper, 13 x 10 inches
Zabriskie Gallery, New York

 Provenance: Estate of the artist

55.
William Zorach
Yosemite, 1920
Watercolor on paper, 13 x 15 inches
Arthur J. Phelan, Jr. Collection

 Provenance: F. B. Horowitz Fine Arts, Ltd.; Babcock Galleries

PLATES

1

Anonymous
City of the Future, ca. 1915-20
Arthur J. Phelan, Jr. Collection

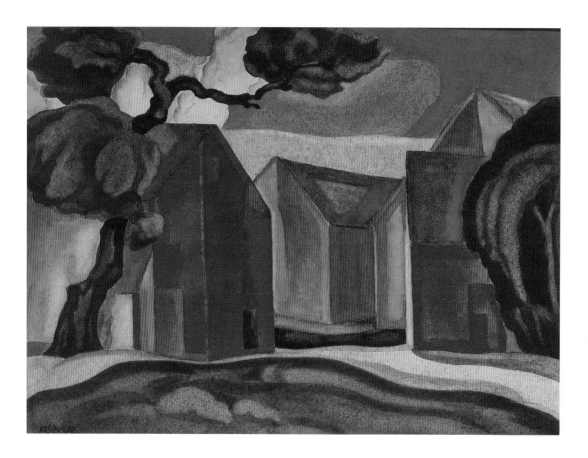

2

Oscar Bluemner (1892-1938)
Harmony in Scarlet, 1925
Mr. and Mrs. W. John Driscoll

3

Oscar Bluemner (1892-1938)
Hillside, New Jersey, 1929
Private collection

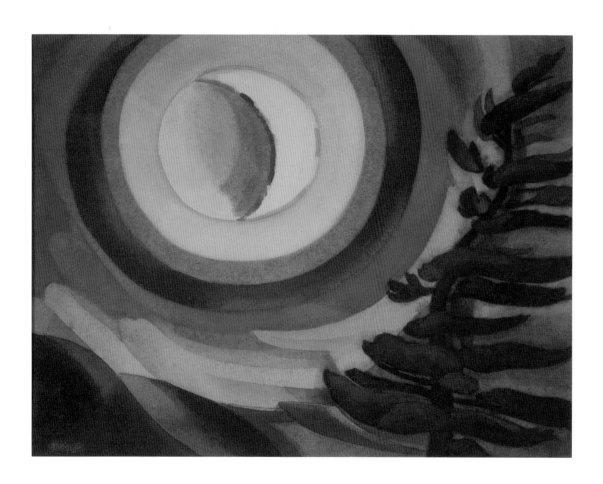

4

Oscar Bluemner (1892-1938)
Moon Radiance, 1927
Private collection

5

Oscar Bluemner (1892-1938)
Sketch for "Port Mystic," Connecticut, 1930
Private collection

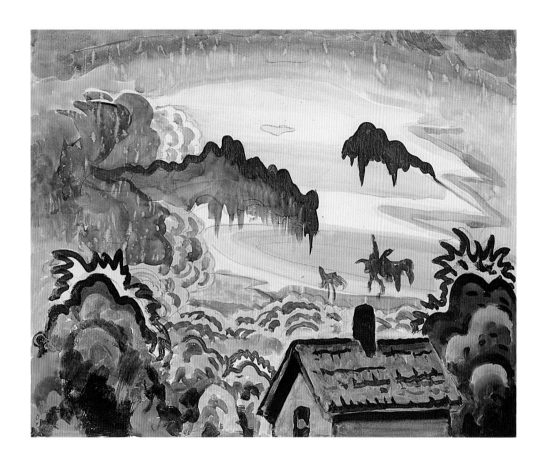

6

Charles E. Burchfield (1893-1967)
Dream House, ca. 1917
Kennedy Galleries

7

Charles E. Burchfield (1893-1967)
The Insect Chorus, 1912
Munson-Williams-Proctor Institute Museum of Art, Utica,
New York. Edward W. Root Bequest

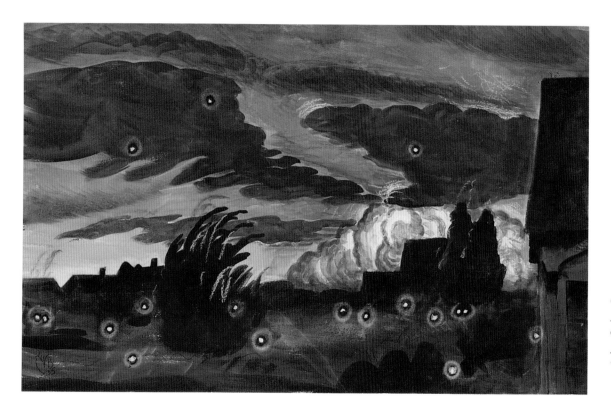

8

Charles E. Burchfield (1893-1967)
Night Scene, 1935
Collection of Whitney Museum of
American Art. Gift of Charles Simon.
77.117

9

James Daugherty (1889-1974)
Contemporary American Literature, late 1930's
The Montclair Art Museum, New Jersey. Gift of
Mr. and Mrs. Jerome Shelby, The S. Barksdale
Penick Fund, The William Lightfoot Schultz
Fund; Mrs. Sigfried Peierls, Mrs. Henry Lang
and Anonymous by exchange

10

Arthur B. Davies (1862-1928)
Untitled, 1924
The Montclair Art Museum, New Jersey, gift
of Dr. and Mrs. Milton Luria

11

Stuart Davis (1894-1964)
Gas Pumps, 1925
Rose Art Museum, Brandeis University, Waltham,
Massachusetts. Gift of Mrs. Teresa Jackson Weill

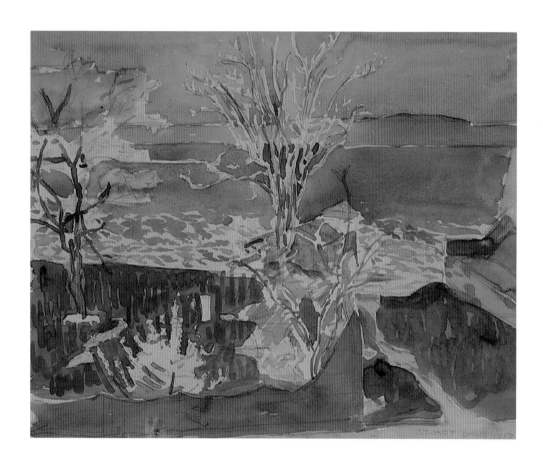

12

Stuart Davis (1894-1964)
Lakefront, 1917
The Montclair Art Museum, New Jersey. Museum
purchase, Lang Acquisition Fund

13

Stuart Davis (1894-1964)
Windshield, 1931
Mrs. Volney W. Foster

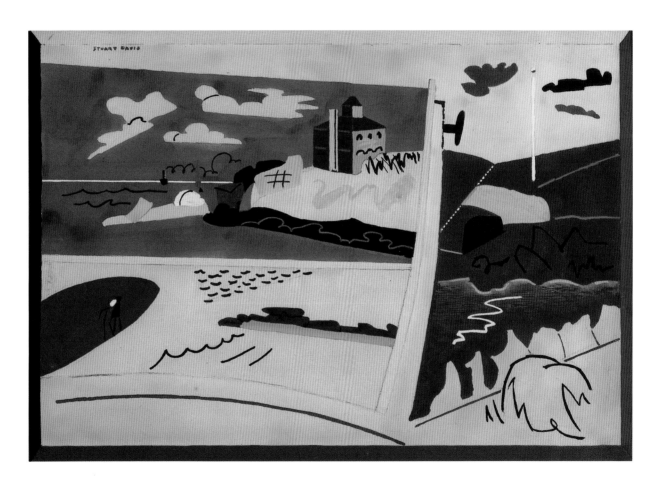

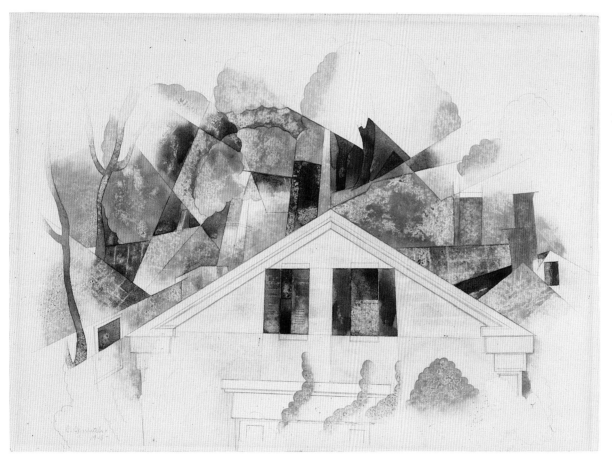

14

Charles Demuth (1883-1935)
Housetops, 1918
Columbus Museum of Art, gift of
Ferdinand Howald

15

Charles Demuth **(1883-1935)**
In Vaudeville: Soldier and Girlfriend, 1915
Private collection

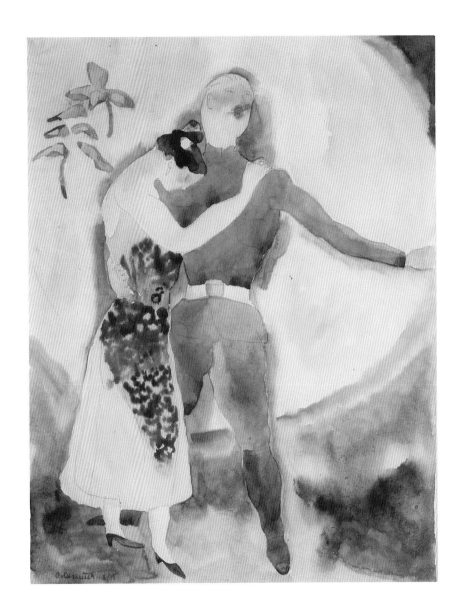

16

Charles Demuth (1883-1935)
Kiss Me Over the Fence, 1929
Private collection

17

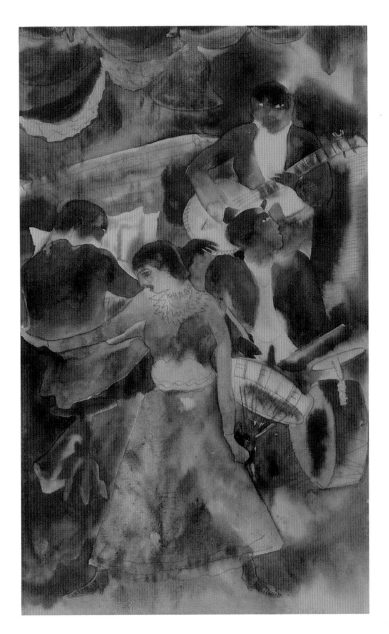

Charles Demuth (1883-1935)
Negro Jazz Band, 1916
Collection of Irwin Goldstein, MD, Wayne, New Jersey

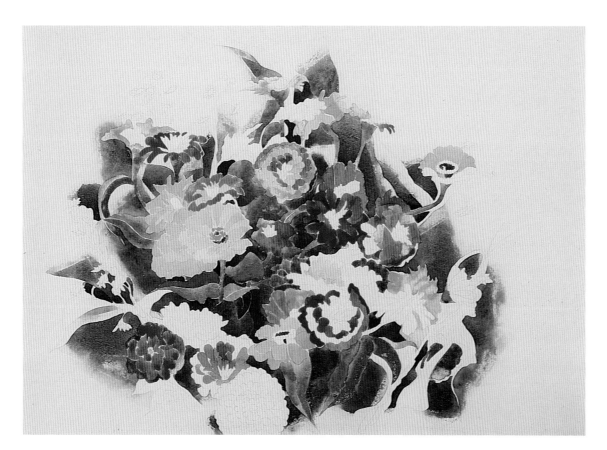

18

Charles Demuth (1883-1935)
Zinnias, 1926
Gerald Peters Gallery, Santa Fe, New
Mexico, and Hirschl & Adler Galleries,
New York

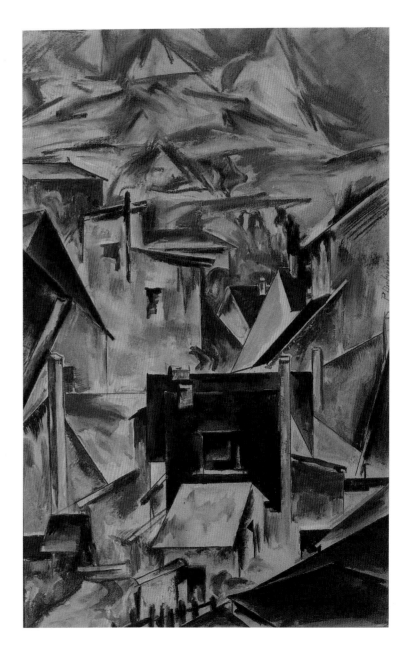

19

Preston Dickinson (1891-1930)
The Black House, c. 1923
Columbus Museum of Art, Gift of Ferdinand Howald

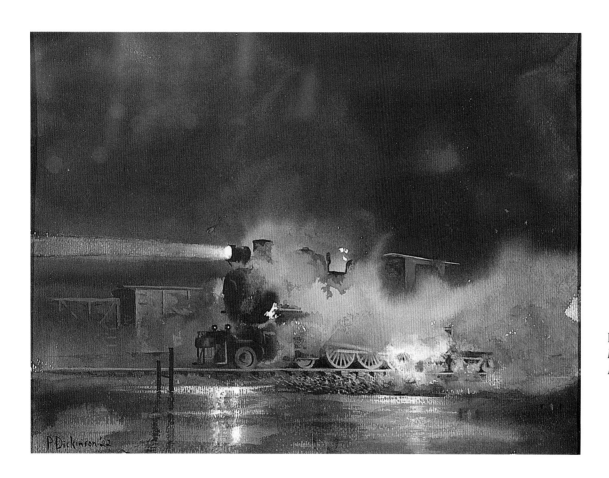

20

Preston Dickinson (1891-1930)
Locomotive, 1922
Arthur J. Phelan, Jr. Collection

21

Arthur Garfield Dove (1880-1946)
Barges, 1934
Baker/Pisano Collection

22

Arthur Garfield Dove (1880-1946)
Dawn III, 1932
The Brooklyn Museum, Dick S. Ramsay Fund, 55.22

23

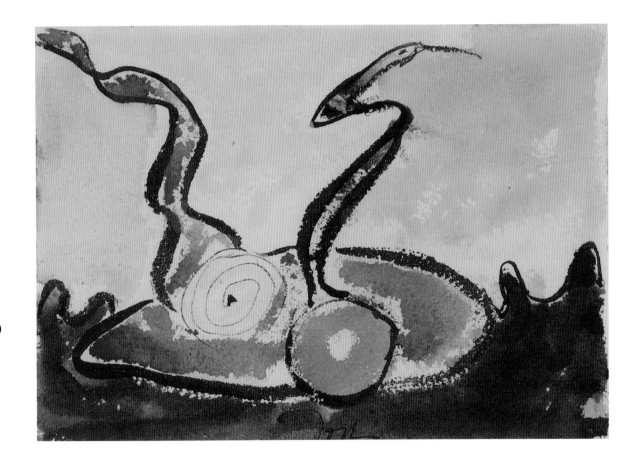

Arthur Garfield Dove (1880-1946)
From an Orchard, 1938
Collection of Elizabeth Moore

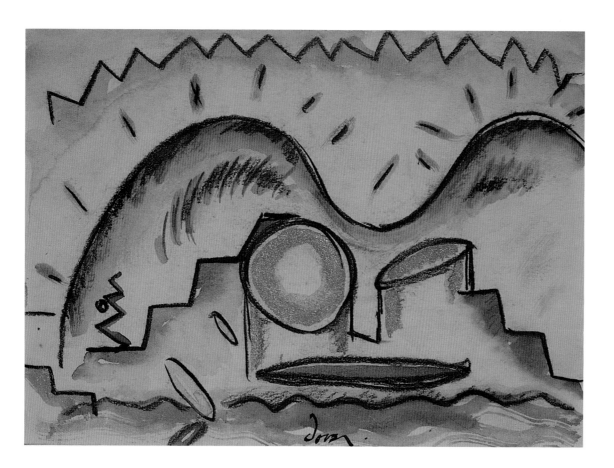

24

Arthur Garfield Dove (1880-1946)
Gasoline Tanks, 1932
Private collection

25

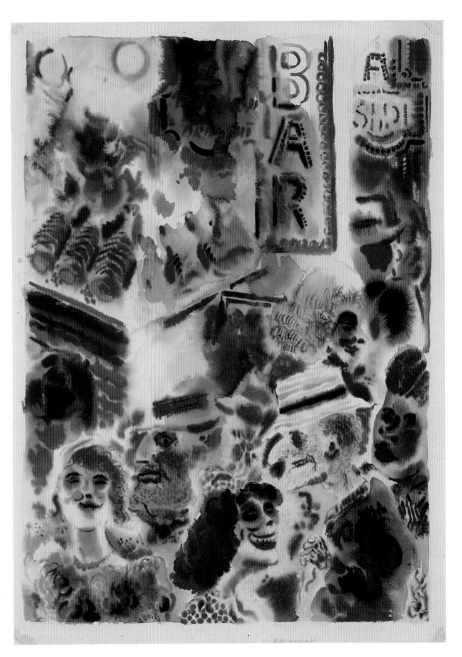

George Grosz (1893-1959)
Broadway, 1934
Anonymous lender

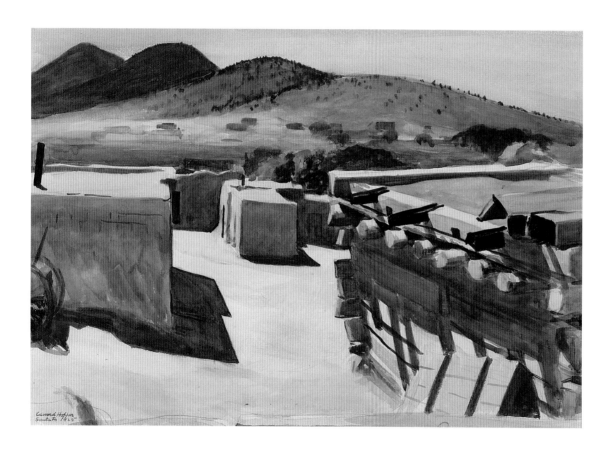

26

Edward Hopper (1882-1967)
Adobe Houses, 1925
Private collection

27

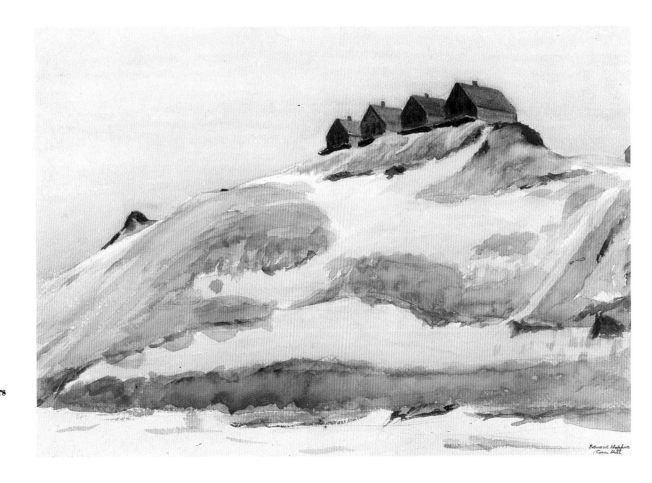

Edward Hopper (1882-1967)
Corn Hill, ca. 1930
Courtesy of Shearson Lehman Brothers

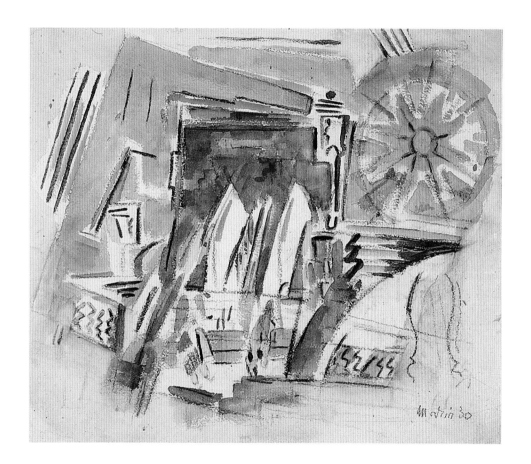

28

John Marin (1870-1953)
Brooklyn Bridge, on the Bridge, 1930
Daniel J. Terra Collection, Terra Museum of
American Art, Chicago

29

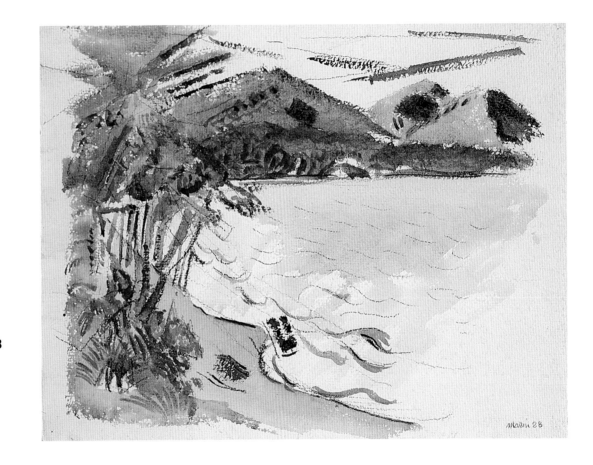

John Marin (1870-1953)
Lake George, New York, 1928
Kennedy Galleries

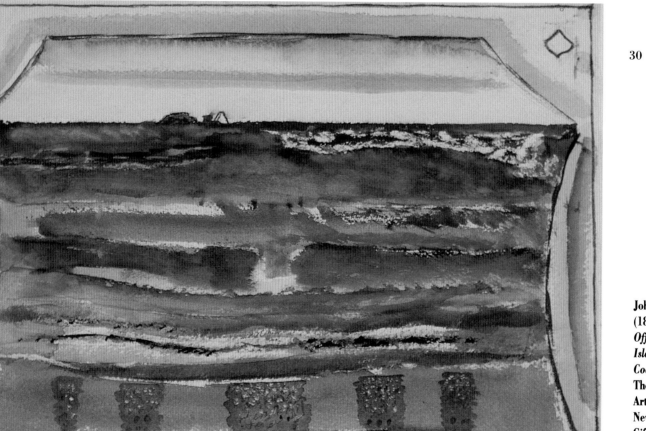

30

John Marin
(1870-1953)
*Off Norton
Island, Maine
Coast*, 1933
The Montclair
Art Museum,
New Jersey,
Gift of Mr. and
Mrs. H. St. John
Webb

72

31

John Marin (1870-1953)
Region of Brooklyn Bridge Fantasy, 1932
Collection of Whitney Museum of American Art.
Purchase 49.8

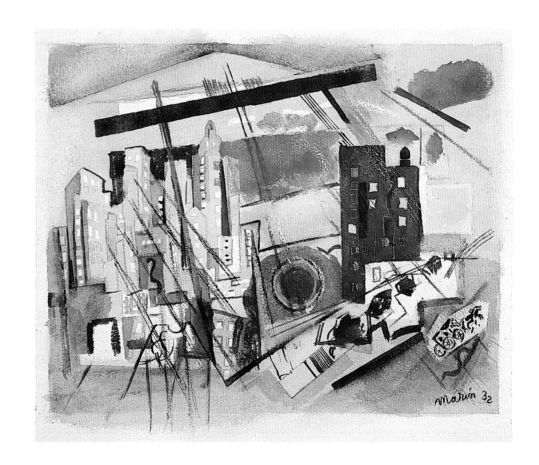

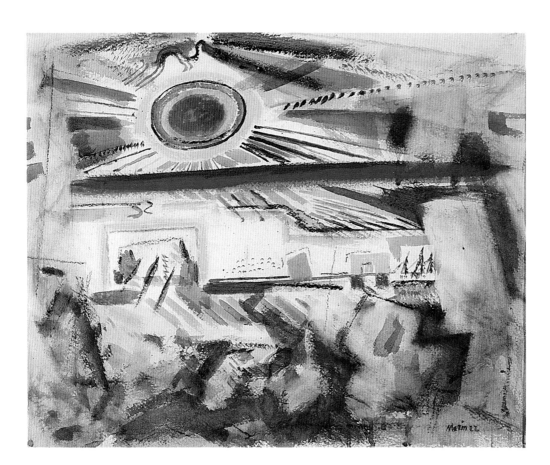

32

John Marin (1870-1953)
Sunset, 1922
Eleanor and Tom May

33

John Marin (1870-1953)
Weehawken, New Jersey, 1910
Courtesy of the Pennsylvania Academy of the Fine Arts,
Philadelphia. Gift of James P. and Ruth M. Magill

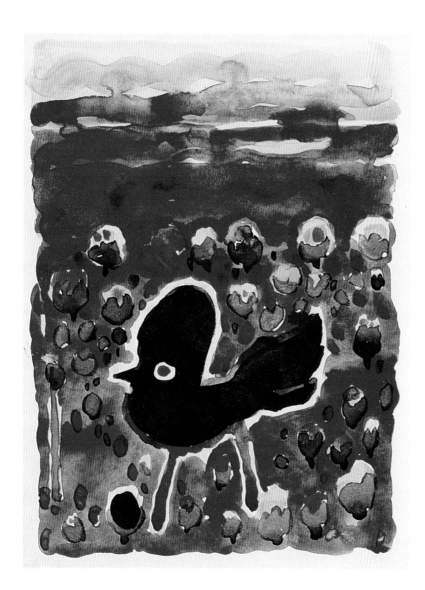

34

Georgia O'Keeffe (1887-1986)
Chicken in Sunrise, 1917
Milwaukee Art Museum, Gift of Mrs. Harry Lynde Bradley

35

Georgia O'Keeffe (1887-1986)
Untitled, 1917
Collection of Françoise and Harvey Rambach

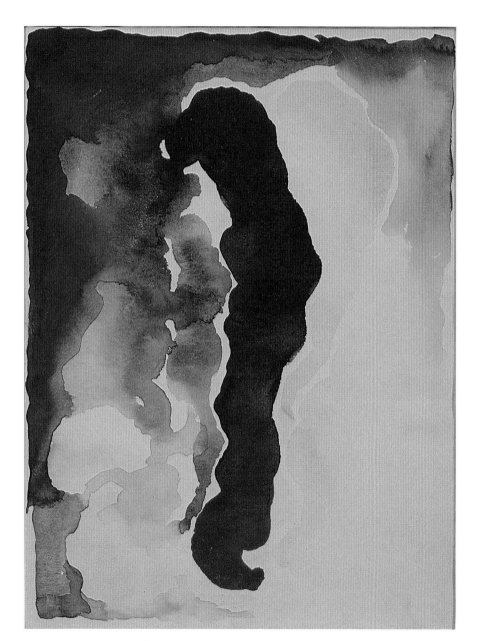

36

Georgia O'Keeffe (1887-1986)
Untitled, 1917
Michael Scharf Collection

37

Georgia O'Keeffe (1887-1986)
Untitled, 1917
Michael Scharf Collection

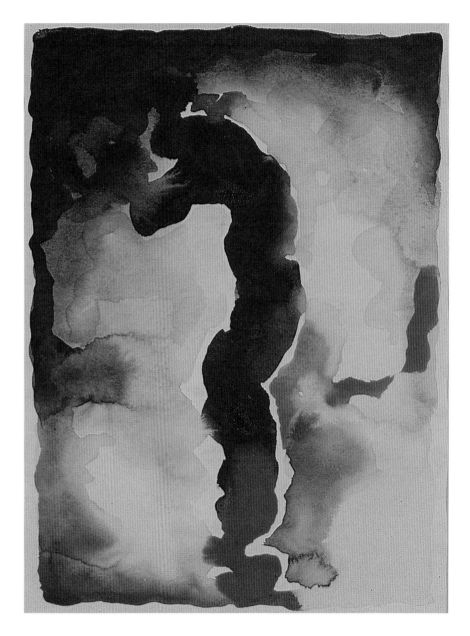

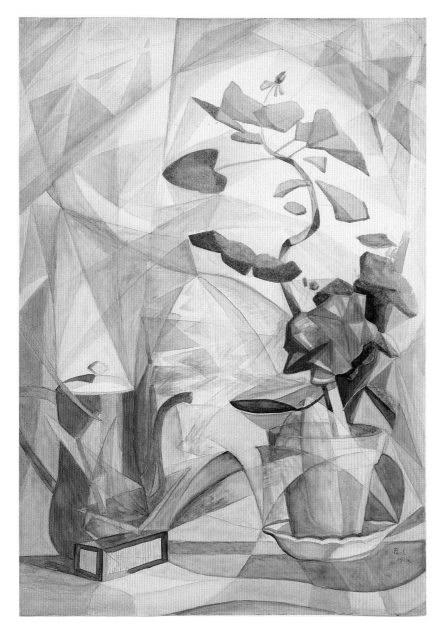

38

Walter Pach (1883-1958)
Untitled, 1914
Collection of Whitney Museum of American Art. Gift of
Francis Steegmuller in memory of Gerda and Beatrice Stein.
85.22

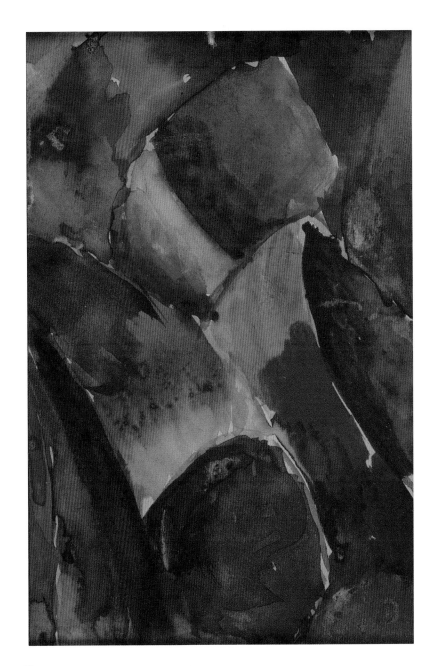

39

Morgan Russell (1886-1953)
Color Study, 1912-13
Morgan Russell Archives, The Montclair
Art Museum, New Jersey

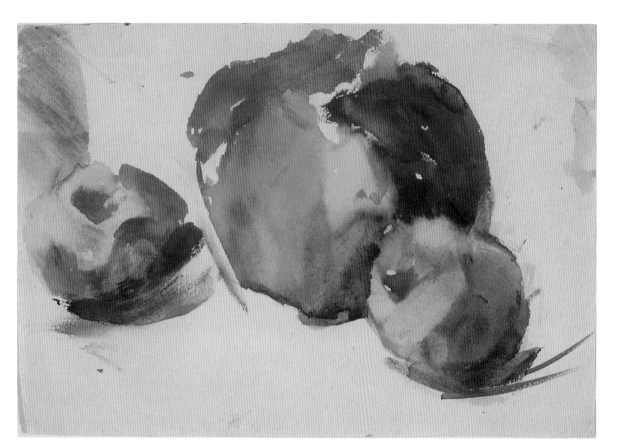

40

Morgan Russell (1886-1953)
Still Life, ca. 1915
The Montclair Art Museum,
New Jersey, Gift of Mr. and
Mrs. Henry M. Reed

41

Morgan Russell (1886-1953)
Study after Michelangelo's "Pietà", 1912
Morgan Russell Archives, The Montclair
Art Museum, New Jersey

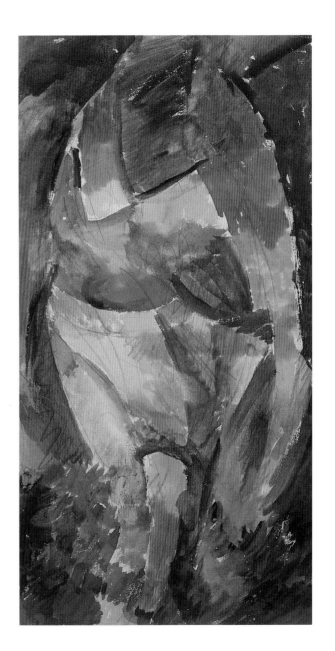

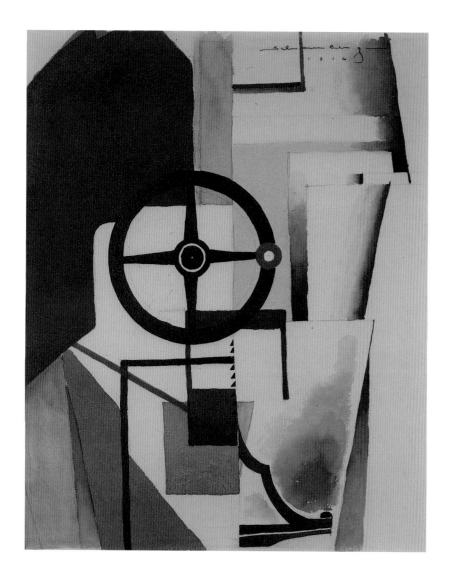

42

Morton Livingston Schamberg (1882-1918)
Composition, 1916
Columbus Museum of Art, Gift of Ferdinand Howald

43

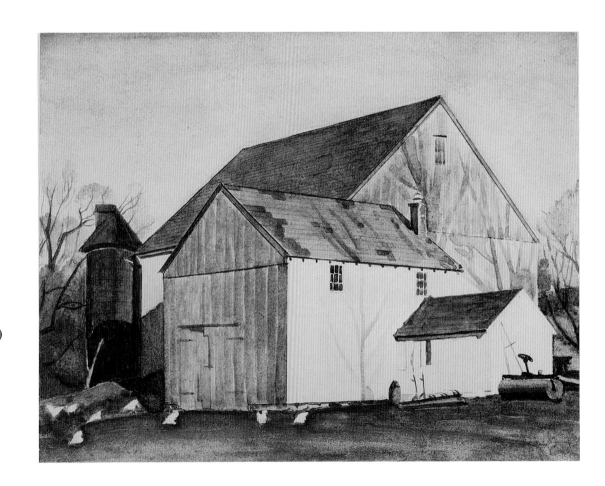

Charles Sheeler (1883-1965)
Bucks County Barn, 1926
San Diego Museum of Art,
Bequest of Earle W. Grant

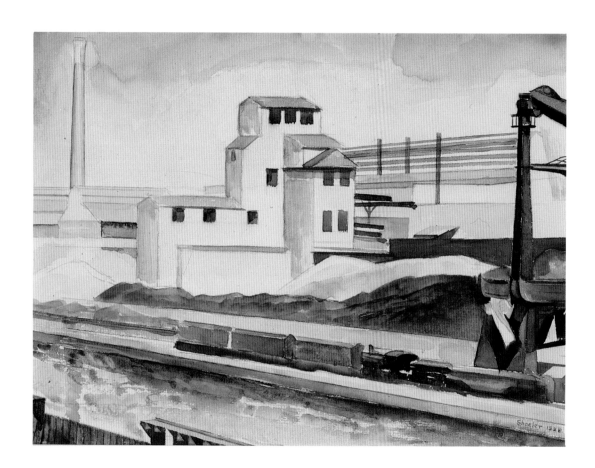

44

Charles Sheeler (1883-1965)
River Rouge Industrial Plant, 1928
The Carnegie Museum of Art, Pittsburgh;
Gift of G. David Thompson, 1957

45

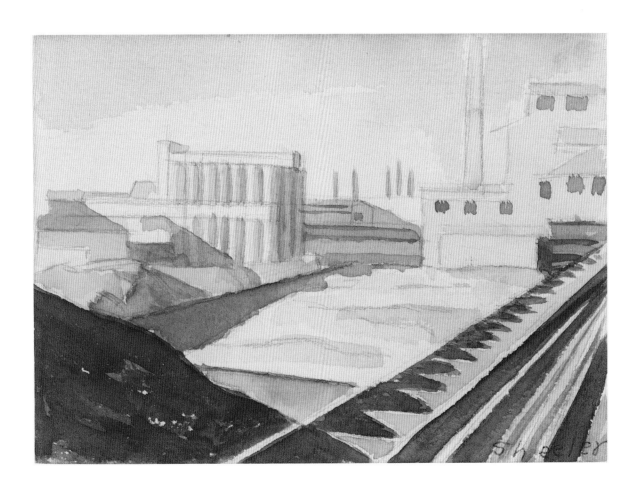

Charles Sheeler (1883-1965)
Study for Classic Landscape, 1920s
Edsel & Eleanor Ford House, Grosse
Point Shores, Michigan

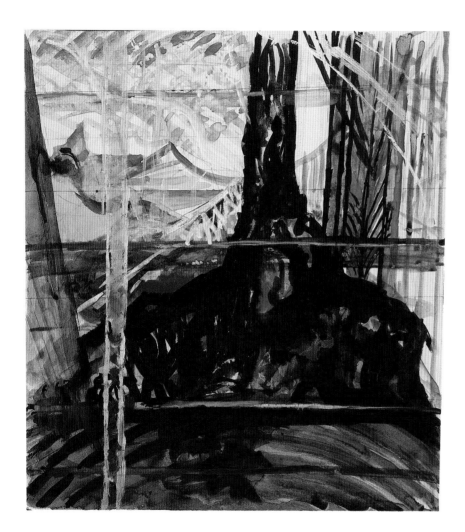

46

Joseph Stella (1879-1946)
Abstraction: Red and Black, nd
Pensler Galleries

47

Joseph Stella (1879-1946)
Geometric Abstraction, ca. 1916
Collection of Robert and Anna Steiner

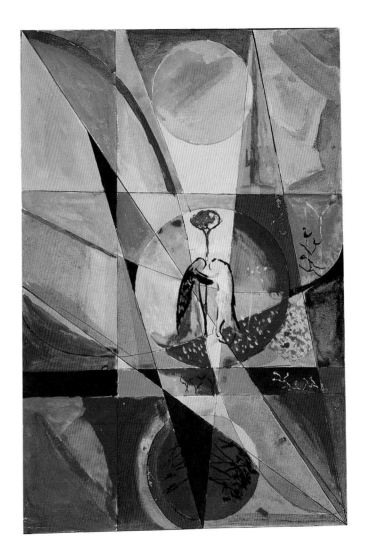

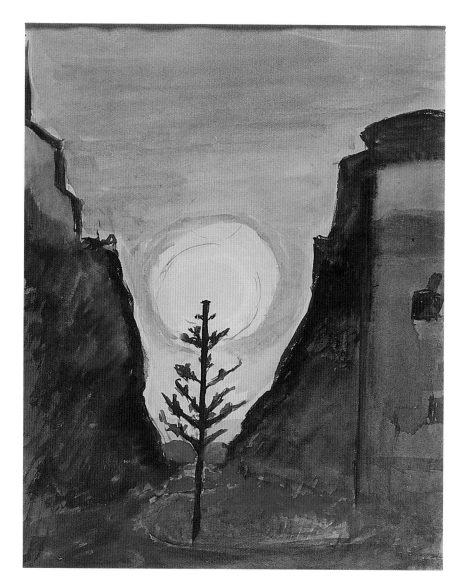

48

Joseph Stella (1879-1946)
Study for "The Little Lake," 1926
The Montclair Art Museum, New Jersey,
Gift of Mr. Bernard Rabin

49

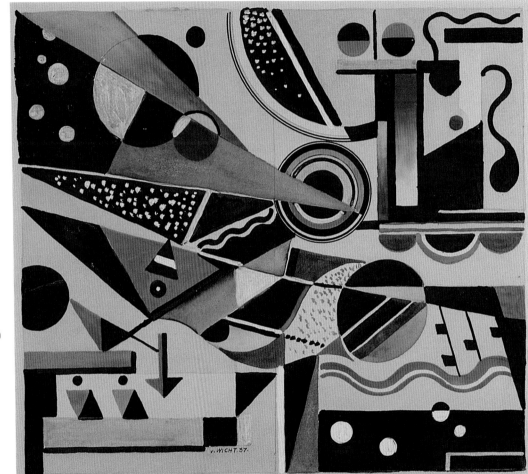

John von Wicht (1888-1970)
Untitled, 1937
D. Bradley and R. Blacher

50

Abraham Walkowitz (1880-1965)
New York, 1917
Collection of Whitney Museum of American Art.
Gift of the artist in memory of Juliana Force. 51.35

51

Abraham Walkowitz (1880-1965)
Untitled, 1914
Michael Scharf Collection

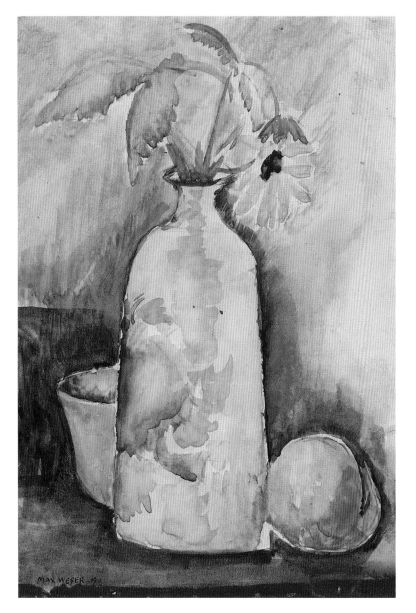

52

Max Weber (1881-1961)
Still Life with Daisy, Bottle and Peach, 1911
Arthur J. Phelan, Jr. Collection

53

Max Weber (1881-1961)
Study for Russian Ballet, 1914
The Brooklyn Museum, Gift of the Edith and
Milton Lowenthal Foundation, 88.205

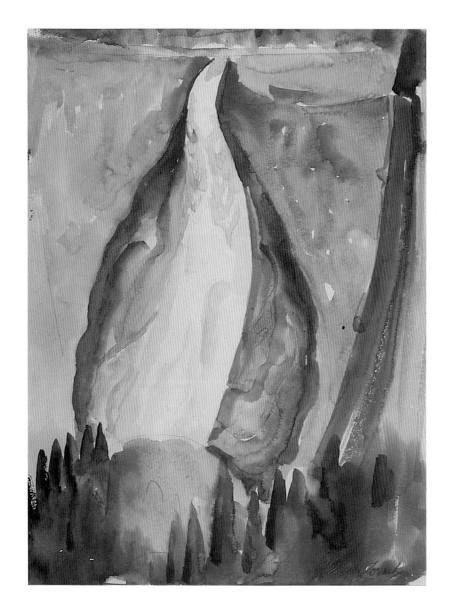

54

William Zorach (1887-1966)
In the Sierras, 1920
Zabriskie Gallery

55

William Zorach (1887-1966)
Yosemite, 1920
Arthur J. Phelan, Jr. Collection

PHOTOGRAPHY CREDITS

PLATES	PHOTOGRAPHER
Cat. 21	John Back, New York
Cat. 13	Chester Brummel, Chicago
Cat. 31	Geoffrey Clements, New York
Cat. 8, 38, 50	Sheldon Collins, New York
Cat. 4, 10, 12, 15, 23, 24, 35, 39, 40	Robert E. Mates, New York
Cat. 11	Muldoon Studio, Waltham, Mass.
Cat. 43	Richard Stoner
Cat. 6	Michael Tropea, Chicago
Cat. 34	Malcolm Varon, New York

For other reproductions, the photographers were not identified.